500 More Digital Photography
Hints, Tips, and Techniques

RotoVision

A RotoVision Book
Published and distributed by RotoVision SA
Route Suisse 9, CH-1295 Mies
Switzerland

RotoVision SA, Sales & Editorial Office
Sheridan House, 114 Western Road
Hove BN3 1DD, UK

Tel: +44 (0)1273 72 72 68
Fax: +44 (0)1273 72 72 69
Email: sales@rotovision.com
Web: www.rotovision.com

10 9 8 7 6 5 4 3 2 1

ISBN: 2-88046-831-0

Designed by Talking Design
Art Director: Tony Seddon

Reprographics in Singapore by ProVision (Pte) Ltd.
Tel: +65 6334 7720
Fax: +65 6334 7721

Printed in Singapore by Star Standard Industries (Pte) Ltd.

500 More Digital Photography

Hints, Tips, and Techniques

The Easy, All-in-One Guide to those Inside
Secrets for Better Digital Photography

Philip Andrews

Contents

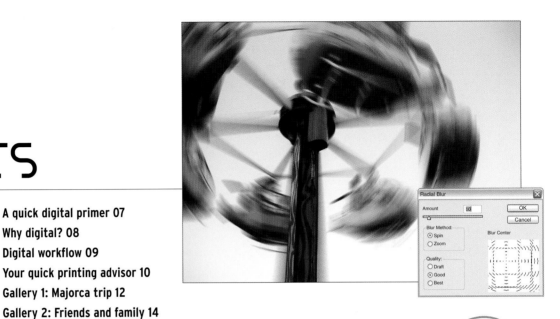

Image Capture

Techniques

Editing

Output

Introduction

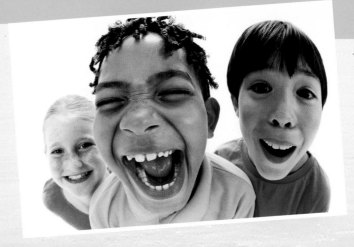

Digital photography is part of all our lives—and like so much digital technology it's moved from being seen as a fad to being accepted into the mainstream at bewildering speed. Top professionals like working digitally, as it gives them far greater immediate control over their work, it saves them film and labor costs, and they can strike up a closer working relationship with clients.

As with all things digital, what works for the professionals also works for you. With digital you can shoot and preview as you go; you need never waste half a roll of film because you want to shoot at a different film speed; you'll have all the control that darkroom experts once had over your film and prints; and you can share your work with your friends.

So don't panic! If you've jumped aboard the digital bus, bought yourself a new camera, and grasped some of the basics (see our previous book, **500 Digital Photography Hints, Tips, and Techniques**) then this is the book for you. In this handy volume, we'll walk you through some of the techniques you'll need in your everyday photography.

We'll also share some insights that will prove useful on those other occasions when you might have your camera with you, such as on vacation, in the cold winter months, or in bad weather conditions. Remember: photography isn't just for when the sun is shining!

Some of the hints and tips will inspire you to think in new ways and to see apparent obstacles as opportunities, while others are hints about good photography practice and for maintaining or packing your gear. There's even a section on printing advice.

This is a book to dip into for ideas. Flick through these pages and you'll also learn some step-by-step techniques for taking your photography into some challenging but easy-to-understand realms. We'll show you editing cheats in Photoshop; how to create stunning black-and-white shots; new ways to improve the appearance of your photographs; how to take great portrait and group shots; how to rescue damaged photographic heirlooms and create antique-looking prints; and how to make stunning panoramas.

The keys to this book—and to your photography!—are fun, creativity, accessibility, and results that you can see in a day. Now, let's get creative!

With digital you can shoot and preview as you go, you'll have all the control that darkroom experts once had over your film and prints.

A quick digital primer...

How does digital photography work? In principle, in much the same way as traditional film photography. Light passes through a lens onto a light-sensitive material, which absorbs and amplifies the light to make it visible. In the "old days" this material was a piece of film; in digital photography it is a photosensor.

This array of millions of light-sensitive cells reads the light falling on it when the camera's shutter is opened. Somewhere in the back of your camera, a microchip interprets the data, which is then stored as a stream of digital bits (short for "binary digits").

This mixture of photosensor and onboard computer is central to what makes digital photography a different process from "traditional" film-based photography. Digital technology puts a far greater level of instant control into your hands—control that previously rested with your local photolab (often with less than satisfactory results!).

With film, the role of the camera is complete once the shutter has been fired. Many decisions about an image are taken beforehand—such as film speed—while the remainder of the process takes place outside the camera.

With digital photography, the camera is a complete image-processing and storage-device, which gives you the option of extending your creativity on your computer. Cynics see this as cheating, but the reality is that photography has always had a helping hand at the developing stage—it is part of the art of photography.

As well as collecting the data captured through the lens, the camera will also determine the structure of the file and may, depending on the type of camera, apply a series of quality-control actions, such as improving sharpness, contrast, and color saturation. In some cameras, the image file may be compressed—a process that reduces the overall data size of the file, measured in kilobytes (kb) or megabytes (Mb), to allow more images to be stored.

Among the many issues discussed in this book will be the relative merits of shooting and/or saving in different file formats, and the pros and cons of applying automatic or manual changes to sharpness and other elements.

Once the image has been processed it is written to memory, usually in the form of a memory card, which is inserted into the camera. Today, high-capacity storage is commonplace and inexpensive, and we'll explore some of the options for storing your work, from cards and disks to portable hard drives and media players.

The 4/3 (four-thirds) standard

Some of you will have a compact camera and be interested in general shooting tips and advice. But for people who want to explore some aspects of the subject in a little more depth, let's talk about lenses!

Many digital cameras, particularly SLRs (single-lens reflex cameras), have been designed around existing 35mm camera film formats and use lenses that were originally manufactured for film-based photography. The problem with this approach is that film and photosensors record light in different ways. Film is sensitive to light falling on it from oblique angles and film-based cameras were designed to take account of this. The image sensors used in digital cameras are most effective when light hits the PD head on. Light striking from any other angle reduces image quality.

The 4/3 format launched in 2003 aimed to optimize the performance of both image sensors and lenses. Under this format, the diameter of the lens mount is designed to be approximately twice as large as that of the image circle. Thanks to this, most of the light strikes the image from nearly head on, ensuring clear colors and sharp details even at the periphery of the image. To achieve the same for existing sensors the lenses would be far too large and unwieldy, whereas lenses manufactured for the 4/3 system are smaller and lighter.

Why digital?

You may already be a convert to the pleasures of the pixel, but here's a brief synopsis of the main advantages—and the disadvantages—of shooting digitally.

Advantages

• **Better results, more often**
Instant picture feedback allows you to make immediate adjustments to camera settings and composition.

• **Cost**
Digital cameras can be more expensive than film cameras—but think of all the money you have saved on film and processing!

• **Control**
With digital cameras you have far greater control over the final image than you've ever had with film. No more relying on poor-quality stores for your shots.

• **Image quality**
A bit controversial, but, compared to like-for-like 35mm cameras, sensors are superior at picking out detail, particularly in low-light conditions.

• **Flexibility**
The number of things you can do with your photographs once they're turned into digital code is amazing. Web sites, greetings cards, DVDs, calendars, and fine-art prints are all within range.

Disadvantages

• **Speed**
Some cameras offer shooting speeds comparable with film cameras, but many don't. If you like photographing action sports or wildlife, then check this out.

• **Power consumption**
Digital cameras eat batteries, so you need to make sure you have plenty of spares available on those not-to-be missed, once-in-a-lifetime occasions.

• **Dust**
Sensors attract dust, which appears on your pictures as gray blobs or bright spots. The sensor must be cleaned regularly—not a simple task given the fragility of the device. Dust specks can be removed using cloning tools in editing software, such as Photoshop, but this can be an irritation after a while.

• **Lens magnification**
The focal length of a 35mm lens is increased by most digital cameras by around 1.5x. For wildlife or sports photography, this "extra" focal length can be a boon, but if you like shooting wide-angle landscapes you may find your wide-angle lens isn't as "wide" as you thought.

Digital workflow

From getting ideas to the "darkroom on your desktop," here's how this simple, dip-in manual works...

This book is set out in a logical sequence that will allow you to get to grips with each of the simple stages of your digital workflow.

Part one deals with the most important aspect of photography: the subject. In this section, you'll find hints, tips, and techniques on taking great travel shots (including etiquette and local customs); taking portraits and group shots; kids and pet photography; shooting in low light, poor weather conditions, and less-than-perfect climates; close-up work; and grabbing stills from videoclips, among other topics.

Part two tackles basic techniques such as digital ISO; white balance; lens usage; exposure; contrast; camera shake; continuous shooting; RAW and other formats; flash photography; and other topics.

Part three explores what you can do next with your images, including Photoshop tips and shortcuts; color management; controlling shadows and highlights; depth-of-field effects; black-and-white images; essential darkroom techniques; and correcting image problems.

And finally, part four gets to grips with the output stage, looking at printers, inks, papers, and related issues.

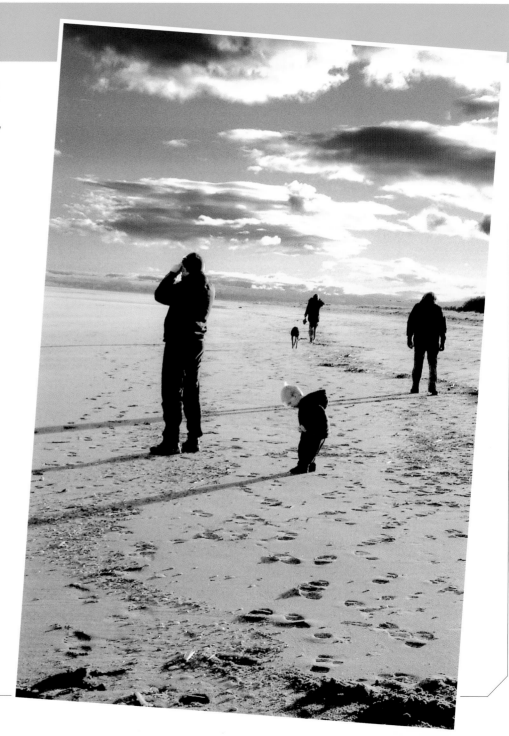

Photography, the digital way

Image capture
The lens projects an image onto the focal plane.

Color filter
The light passes through the colored filters and is analyzed as an analog signal.

Sensor
The light-sensitive sensors turn the image into pixels –a uniform pattern of microscopic squares, each containing brightness and color information.

Analog signal
The camera then sends an analog signal to the in-camera computer.

Image analysis
The final image is constructed by microchips and software and turned into a binary digital file.

Storage
The digital signal is sent to the storage device– usually a memory card inserted into the camera– where it is recorded as a digital file.

Your quick printing advisor

Before we get into the hints and tips, we begin each of the books in this series with some general advice about a specific area of interest.

Select print options
Before proceeding to print, make sure that you select print mode, paper type, paper size, print layout, and print quality from the control panel. You can select between single or multiple pictures on a page as well as an option to create an index print of all the pictures.

Preview picture and print
If you have a printer with a built-in preview screen, check the displayed thumbnail before pressing the start button to begin printing. If you are using a paper roll, make sure it is loaded properly in the printer.

Papers and dots per inch (DPI)
The surface of the paper is critical to how much of the detail produced by your printer and your careful image preparation ends up in the final print.

Choosing a paper type in your printer settings changes the dots per inch (dpi) that the ink-jet head will place on the paper. Papers with finer surfaces, or better coatings, can accept finer dot quality, or higher dpi settings.

Adjusting color to suit
Using the manual controls in the printer dialog allows you to make adjustments to suit any color change, or cast, that results from the paper and ink combination rather than from shooting conditions. Settings can be saved as custom options and used with the same ink/paper combination in the future.

Previewing your prints
Most image-editing software includes controls for adjusting how the picture is positioned on the page before being sent to the printer. In Photoshop, the main screen used for these adjustments is the File > Print with Preview dialog (File > Print for Elements users).

Page setup
Confusingly, both Photoshop and Photoshop Elements provide a second way to set up the paper size. The File > Page Setup dialog contains settings for the size and orientation of the paper that will be used by the default printer.

in the editor when the feature was selected, or multiselected from the thumbnails in Elements' Organizer workspace.

Direct printing

Load the paper and insert the camera's memory card into the printer. Some models have multiple memory-card slots to suit the different cards that are available; others require you to use a card adaptor to match card to slot.

Shooting for direct printing

Most printer models that contain the direct printing option can only output photographs saved in the JPEG format. If you intend to print directly from your camera's memory card, ensure that your camera is set to capture in JPEG mode only.

Print online

Photoshop (CS2 +) and Elements (3.0 +) give you the ability to output your photos at a professional processing lab via an Internet connection. Go to File > Print Online or File > Order Prints options.

Multiple photos in Photoshop

Photoshop users can access multiple print features via the File > Automate > Contact Sheet II and File > Automate > Picture Package options.

Multiple photos in Elements

Photoshop Elements for Windows also contains an extra print control that allows the user to output several images on the same page. The File > Print Multiple Photos option arranges several pictures that were either open

Gallery 1: Majorca Trip

Capture that holiday of a lifetime, mixing the posed with the informal, the urban with the natural world...

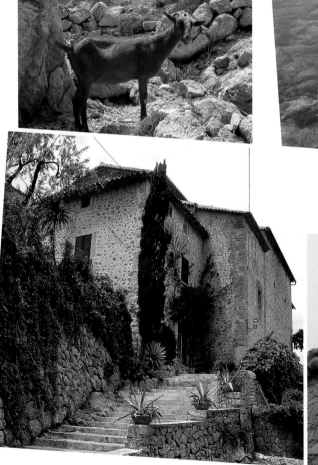
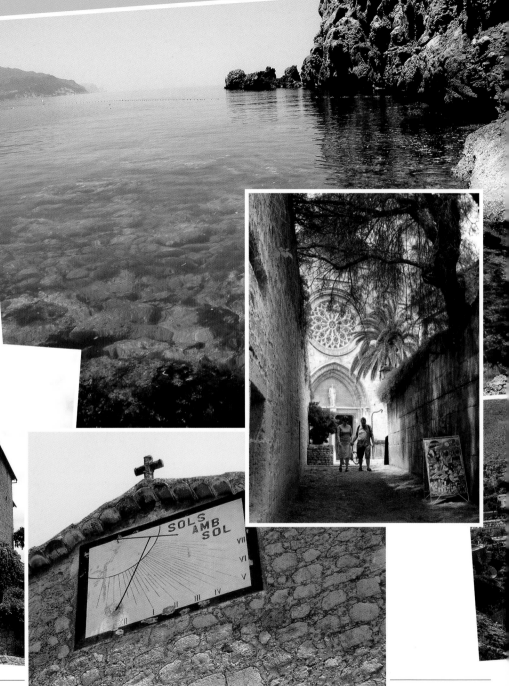

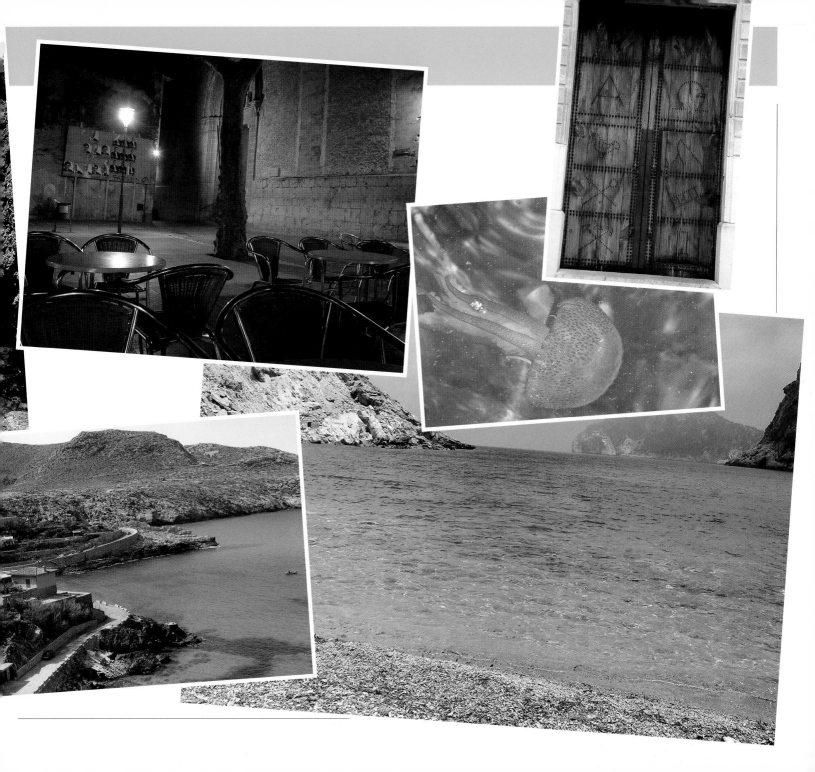

Gallery 2: Friends and Family

Portraits can be formal and directed, or spontaneous and natural. Hone your portrait-taking skills while you're out and about with friends and family...

Capture

Travel Pictures

One of the most enjoyable and rewarding activities for any photographer is capturing images of the interesting people, amazing scenery, and wonderful atmospheres in the places we visit while traveling.

001 Be prepared

Good travel photographers always undertake some pre-trip organization to help ensure that they are ready for the challenges of shooting in another country.

002 Do some research

Find out what the climate and weather conditions will be like at the time of your trip. Check out the voltage of the local electricity supply and find out how easy it is to obtain extra memory cards and batteries if you need them.

003 Check your equipment

Make sure that your equipment is clean and in good working order. If you haven't used your gear for a while, it is worth taking a few test shots to ensure that all features are functioning well. If you have any doubts, book your kit into your local dealer center for a service before you leave.

004 Imagine you are there

Think about the amount of gear you plan to take. Pack the equipment into your camera bag and test-carry the collection to check that the bag is suitable and that you are not overloaded. Imagine the shooting scenarios you will encounter and check that you have the right equipment to capture them. You will have to strike a balance between taking enough gear for most picture-making opportunities and attempting to travel light!

005 Shoot the way you travel

The best way to capture great images, as well as those that will hold the most vivid memories upon your return, is to shoot in the same way that you travel. This means capturing photographs of the things that interest you.

006 Follow your passions

Fill your frame with images of local people going about their daily lives. These pictures may be formal, carefully constructed portraits that are up-close and personal and taken with the cooperation (and assistance) of the sitter, or they might follow a more candid approach and be glimpses of street life.

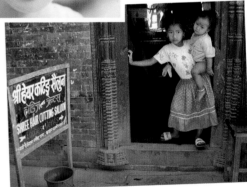

Don't be afraid to place yourself in the action. Here, the reflective surface of a shop column positions the photographer in a Parisian street.

008 Shoot to a theme

Some photographers shoot to a theme, which can help provide a link between the images in a small series. The theme may be followed for the extent of shooting at one location, or may be used as a storytelling device that holds together all the photographs for your whole trip, such as "A gourmet eats his way around Europe."

007 Provide a context

Don't take just one picture of your chosen subject; shoot several photographs trying different angles, compositions, zoom settings, and areas of sharpness.

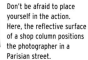

009 Be aware of local customs!

It's easy to overlook the customs and cultural sensitivities that people in some societies hold about having their photograph taken. Before planning a trip, find out how local people are likely to respond. In some countries, it may be acceptable to photograph men but not women. If in doubt, always be respectful. Never take images of people when you have been asked not to.

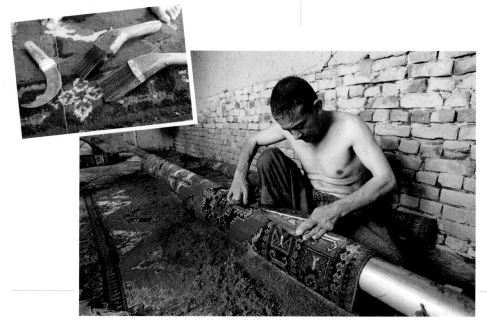

EXPOSURE TIPS

010 Watch your exposure

Most digital cameras contain a range of autoexposure modes designed to assess the light in a scene and then choose an aperture and shutter that will allow enough light through the lens to expose the sensor correctly. In most scenarios systems work well, but in up to ten percent of all shoots the meter in the camera can be fooled into providing an f-stop and shutter speed combination that produces images too dark or too light. On these occasions, you need to help your camera out by intervening in the exposure process.

011 Tricky exposure solution 1

If the camera allows for the manual override of automatic settings, you can change the shutter speed (or aperture) up or down to suit the lighting. Just check when you change the aperture, for example, that the camera doesn't automatically compensate by adjusting the shutter speed setting. If this happens, you probably have the camera set on an auto mode and will need to switch to manual.

012 Tricky exposure solution 2

Systems with no manual functions usually allow the locking of exposure settings. With the camera pointed at a part of the scene that is most representative of the exposure you need for the photograph, you can half-press the shutter button to lock exposure. With your finger still on the button, it is possible to move the camera and recompose the image, taking the picture using the stored settings.

013 Tricky exposure solution 3

A third method is to compensate for exposure problems by setting the camera to purposely over- or underexpose the image by 1, 2, or even 3 stops' worth of exposure. This is achieved via the exposure compensation feature. Usually taking the form of a button positioned on the base of the camera, this feature allows you to override the camera's current settings. With most models you can make the exposure adjustment by holding down the button while turning the command dial. Be sure to switch back later!

014 Autoexposure modes: Auto or Program

The camera determines the shutter and aperture settings automatically based on the light in the scene. This is okay for "point and shoot" occasions, but does not generally provide the extent of control needed for more creative photography.

015 Autoexposure modes: Shutter Priority

The shutter speed is set by the photographer and the camera adjusts the aperture automatically to suit the light in the scene. This is great for controlling how motion is recorded in a scene.

016 Autoexposure modes: Aperture Priority

The aperture is set by the photographer and the camera adjusts the shutter speed automatically to suit the light in the scene. This is best used to allow good control over the zone of focus in a scene.

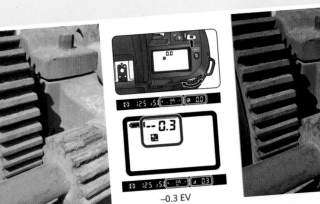

−0.3 EV

TRAVEL PHOTOGRAPHY EQUIPMENT

017 Choosing gear for travel photography

The four key questions you should ask yourself when deciding what photographic gear to take when traveling are:
• Does it allow me to photograph in the way that I like?
• Is it light?
• Is it easy to carry?
• Do I really need it?
If you answer "yes" to all the questions then you should definitely take the item. If there are "no" answers then consider leaving it.

018 Camera bag

A good camera bag is one that distributes the weight evenly across your back, shields your equipment from bumps and moisture, and can be easily accessed while you are on the move. Don't go for the biggest model, as this will encourage you to pack more gear for the trip and you'll simply end up leaving the bag behind because it's too heavy and just taking your camera. Look for adjustable padded shoulder and waist straps, as this helps ease back strain on a long day's shooting.

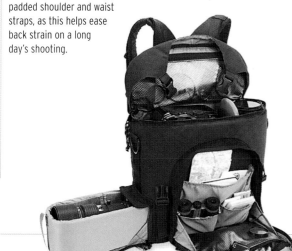

019 Mini tripod

The emphasis here is small, compact, and lightweight. All the major camera companies now make portable tripods that you might not use in the studio, or when shooting close to home, but which work well enough in the field.

020 Zoom lens

Travel shooting always presents the photographer with a variety of shooting scenarios. Sometimes the focal point in a scene is very close to hand, while at the next instant it is in the distance. This is the territory of the big zooms—that is, variable-focal-length beasts that start at a wideangle setting and then work their way through standard focal lengths until they reach telephoto. Try to obtain a lens that will cover 28-300mm and yet still weigh little over 14oz (400g).

021 Memory cards and portable storage

As the resolution of cameras increases and photographers shoot in RAW format before editing, it seems even the biggest memory cards never have enough space. The short answer is to buy more cards, but as a storage option, the average memory card is fairly expensive when evaluated on a cost-per-Megabyte (Mb) basis.

022 Portable HDs

A popular alternative is to take a portable storage unit. These are hard drives with a preview screen—many media players, such as some iPods, can be used in this way.
After a day's exploring, transfer shots from your memory cards to the hard drive, emptying the cards for the next day.

023 Extra lenses?

If you want bigger maximum apertures that remain fixed throughout the zoom range, you will need several lenses that cover your ideal focal range. Keep in mind that each extra lens you take adds to the weight and changing lenses in some conditions risks introducing dirt to the surface of your digital sensors.

PHOTOSHOP AND THE TRAVEL PHOTOGRAPHER

024 Take the gear you need for the day

Even if you have been pretty careful with the equipment you take away with you, sometimes the camera bag is just too heavy to carry for long periods of time. If this is the case, leave a couple of pieces of lesser-used kit back at the hotel room and spend the day lighter on your feet. Better still, choose the kit you take with you by the subjects that you will be photographing on the day.

025 Allow for more shots than you think you need

Estimate the number of shots you will take for the day and then take enough camera card space for twice that number. This will ensure that you don't miss that all-important, once-in-a-lifetime moment simply because the "full" sign is showing on your screen. (Bear in mind you can now buy multigigabyte-capacity cards, so don't limit yourself to low-capacity cards).

027 Download each day's shooting

If you don't have a portable storage device, consider burning the day's shooting to CD or DVD. Some labs supply a write-to-disk service for travelers so that you can walk into the shop with a full card and walk out with the images stored safely on disk. Avoid taking your own laptop, though—and check that CDs won't be a customs problem later!

026 Delete missed shots to free up card space

One of the wonders of digital photography is the fact that you can review the success of your images immediately after taking them. This is the prime time to delete the frames that didn't quite work the way that you wanted and ensure that you have enough space for (hopefully) more successful images.

028 Keep a journal

Note down all the interesting details—the ones you are sure you will never forget on the day, but which always slip your mind when you are trying to remember where and when a picture was taken. If you are lucky enough to have a digicam with voice-recording facilities, take some quick soundgrabs and store them along with your pictures for later reference.

029 Removing unwanted areas

The Clone or Rubber Stamp tool is a useful feature for removing dust and marks on images, but even more useful is the Healing brush (Photoshop 7+). Working in much the same way as the Clone tool, the user must select the area to be sampled first (using the Alt key and a mouse click) before "painting" over the area to be repaired. Unlike the Clone tool, it merges the painted area with the detail beneath and disguises the change. Useful for quick fixes!

030 Creating a digital slideshow

Photoshop and Photoshop Elements both provide you with ways to create digital slideshows and save them in the very accessible PDF or Acrobat format. What's more, your audience can change the slides to keep pace with their own interest level.

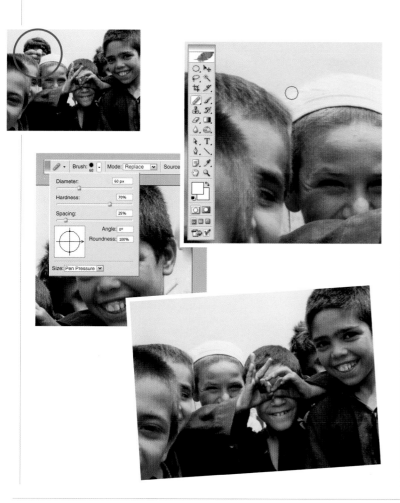

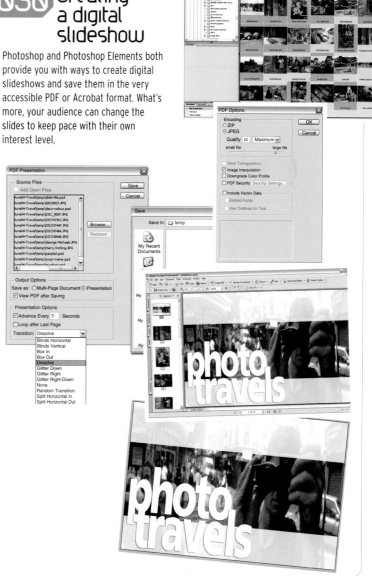

Still lifes
Photographers have had a long and illustrious tradition of shooting still life setups. Whether the still life is a carefully orchestrated advertising campaign for the newest fashion accessory, a random collection of found objects located in a secondhand store, or an assemblage of your favorite personal items, the idea of taking time to arrange and light a subject is very appealing to many imagemakers.

031 Shooting still life educates the eye

Photographing still lifes is one of the best ways to learn about composition, lighting, and camera control, as it gives you the time and space to make the type of considered decisions that are not usually possible with day-to-day shooting.

032 Shoot and review

Incorporating a digital camera into the still-life shooting process means that you can shoot and immediately review your results. Start by setting up your camera on a tripod, arranging your still life objects and adding a background. Next, compose the subject and set up your lighting. Take a test shot and check your results on the camera's monitor. Adjust and reshoot.

CONTROL LIGHTING

Exploring lighting while photographing still life is both interesting and creative, but be prepared to learn to become a lighting maestro one step at a time.

033 Adjusting the color of light

Try to match the White Balance (WB) setting of your camera with the color of your lighting. This ensures that white objects in your image stay white rather than take on an unwanted "color cast" caused by the color of the lighting.

Light source	White Balance setting on a digital camera
Daylight, sun and clouds	Daylight
Overcast day	Cloudy
Windowlight, no sun	Custom or Preset
Flash	Daylight
Warm, white florescent tubes	Florescent
500w lamps (3200k)	Tungsten
100w domestic lamps	Custom or preset

034 Other White Balance options

Many photographers prefer to capture a couple of frames using the Auto White Balance (AWB) setting first. Then, if they are unhappy with the overall color in the picture, they opt for the camera setting linked specifically with the light source illuminating the setup. For most situations, either of these two approaches will give you good results. However, in some mixed lighting scenarios it may be necessary to use a custom or preset WB setting. This measures the color of the light and creates a custom setting for the scene.

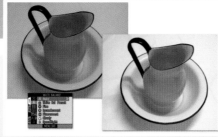

035 Learn the Auto White Balance (AWB)

Use the AWB function to assess the color of the light in the general environment and to neutralize the midtones of the image. As with most "auto" camera features, this setting works well for the majority of "normal" scenarios. In particular, the feature does a great job with scenes that contain a range of colors and tones. You may have difficulty with subjects that are predominantly of one color, or that are lit from behind. Remember that some subjects, such as cream-colored lace, are off-white, so the use of the Auto feature would remove the subtle hue of the original.

036 Preview!

Apart from these exceptions, most cameras' Auto features produce great results that require little or no post-shooting color-correction work. If in doubt, try the auto setting first. Check the results on the preview screen of the camera; if there is a color cast still present move onto some more specific white balance options.

037 Reset!

Remember that, as this is a customized process, if you decide to turn a light off or rearrange your subject, then you will need to remeasure and reset your White Balance.

038 Customize your white balance

In a perfect world, the still life you want to shoot will always be lit by a single daylight-balanced source. In reality, most scenarios are illuminated by a variety of different colored lights. In these cases, you should use the Custom, or Preset, White Balance option in your camera. Based on video technology, this feature works by measuring the light's combined color as it falls onto a piece of white paper, or in some cases a gray card. The camera then compares this reading with a reference color swatch in its memory and designs a WB setting specifically for your shooting scenario. You are now set to shoot your still life secure in the knowledge that you will produce color-cast-free images.

039 Determine light direction

Start with one light source. This may be a single bulb or floodlight, an open window, or the sun. Keep in mind that the aim of most improvised lighting is to give a fairly natural appearance, as if lit by the sun. This means having one predominant source of light and shadows, positioned high rather than low down. Set up your light source (a spotlight, for example) somewhere above camera height and to one side of the subject. Adjust it to give the best lighting direction for showing up form, texture, and shape. With the main light set, you can add a second light or reflector to the environment to help lighten shadow areas.

040 Adjust lighting contrast

Be careful with the contrast (the difference in brightness between lit and shadowed parts) in your still life pictures. When photographing outdoors in daylight, the sky always gives some illumination to shadows, but in a darkened room direct light from a single lamp or window can leave very black shadows. Unless you want a stark-looking image, you will need to fill in shadows with just enough illumination to record a little detail, using a large white card reflector or a second weaker light source. A reflector throws back very diffused light toward the subject and, since it does not produce a second set of clearly defined shadows, you preserve that "one light source," natural look. This is regularly used by pros to vary the darkness of the shadows on the unlit side of their subjects.

041 Reduce the brightness of a second light

When using a second light source of the same power, reduce its strength by moving it further away from the still-life setup. Moving the second light so that it is twice the distance from the setup will reduce its strength to a quarter.

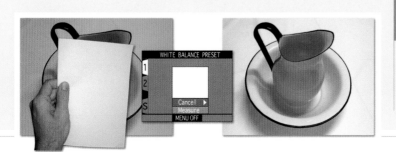

LIGHTING FOR DIFFERENT SURFACES

Over the years, photographers have developed specific lighting setups that work well with different subject surfaces. These setups, sometimes called lighting schema, provide a good starting point when lighting still-life subjects.

042 Lighting for textured objects

Lighting for texture is all about using strong directional light that skims across the surface of the object, producing shadows as it goes. To show texture, you must create shadows, so move your light or subject until you see the texture become pronounced. Don't use soft or diffused light, even if using strong direct light results in some shadow areas being dark and featureless. Set up your main directional light and then use a reflector to help fill in the shadow regions.

The textural qualities of both the blocks themselves and the greater assemblage are emphasized by skimming strong directional light across the surface of the subject. In this way, the shadow provides the sense of texture. (Image courtesy of www.ablestock.com)

043 Lighting for silverware or glossy surfaces

Highly reflective surfaces such as chrome, or highly polished glossy paint, need to be treated quite differently from textured surfaces. Aiming a strong light directly at the surface will only result in a bright hotspot with the rest of the object looking dull and dark. Professionals light these subjects by surrounding the object with a "tent" of diffusion material that they light through. Alternatively, they shine their main light onto a series of white reflectors. With a tent setup, the silver or gloss surface reflects the white surfaces of the inside of the tent (or reflectors), giving a suitably glossy feel to the final photo.

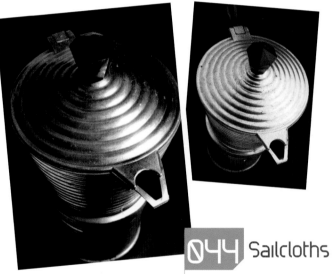

044 Sailcloths

Though this sounds a little tricky, in practice, a successful silverware photograph can be taken by suspending a piece of white sailcloth over the top of the object and then passing the light through the diffuser. The camera is then positioned so that it is to the side of the diffuser and is not reflected in the jewelry surface. Or use diffused (or window) light and surround your subject with white reflectors.

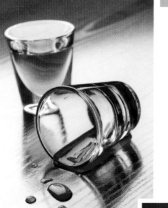

045 Lighting for glassware or transparent objects

Glass objects pose a similar problem in that directing a light onto the surface produces a bright hotspot and doesn't show the translucency of the subject at all. To solve this problem, glassware should be lit from behind. Often this involves a setup in which light is directed onto a lightly colored background and then shooting through the glass object to the lit surface behind.

046 Challenge yourself

Stretch your skills by trying to light a still-life object that contains more than one surface type. For instance, a glass bottle with a silvered label would require you to light the bottle from behind, and the label using a broad diffused light.

047 Shooting without a studio: strong, direct lighting

As we have already discussed, texture in a photograph is emphasized by using strong, direct lighting that skims across the surface of the subject. The sun is a natural light source that provides just this quality of light. By moving your subjects around to suit the direction of the sun or even waiting till later in the day when the sun is a little lower, it is possible to replicate the effect of strong "textural" studio light.

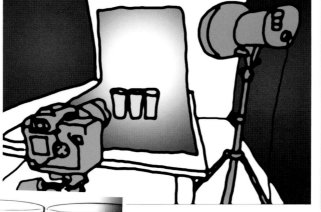

048 Shooting without a studio: soft, diffused lighting

What if you are photographing outdoors or without special lighting equipment? The answer is to apply the same principles outlined here but substituting the light sources that are available in the location. An unshaded window can be used as a substitute for a soft diffused light source. Alternatively, shooting on an overcast day will provide the same quality of light that using a very expensive softbox studio flash setup does.

ESSENTIAL EQUIPMENT FOR STILL LIFE PHOTOGRAPHY

049 White reflectors

Probably the most underrated piece of photography kit ever, the humble white reflector can convert a one-light setup full of dark impenetrable shadows to a sophisticated lighting scheme in a few seconds. White card, a thin sheet of polystyrene foam, or even a remnant of white fabric can all be used to reflect light back into the shadows of your picture. No real photographer would leave home without one.

050 Black reflectors

Sometimes called "gobos" in the industry, a black reflector is great for holding back light from areas in the picture where you don't want it. Adding a black reflector to a diffused lighting setup will give the objects that it is placed next to greater definition. Some matt black card or a piece of black material is all that is needed for a black reflector.

051 Silver reflectors

Silver (or gold) metallic reflectors provide stronger and more direct fill for shadow areas. Used extensively in the movie industry to lighten the shadow areas of outdoor scenes, a simple silver reflector can be made by sticking a sheet of aluminum foil to a piece of card. You can buy collapsible reflectors in photography shops. These fold away—useful if you want to take a reflector with you on your travels.

052 Diffusion sheets

Created from such materials as tracing paper or drafting film (or even sailcloth) stretched over a wood or metal frame, these devices are placed in front of light sources to soften the light quality. Large diffusers can be used outside to convert strong direct sunlight to something like soft diffused windowlight.

053 Variety of White Balance options

It is important when dealing with varying light conditions and a range of light sources that you are able to control the way that the colors are recorded by your camera. Be sure that you understand and can use the various White Balance settings that your camera provides. In particular, make sure that you can use auto, light-source-specific, and preset or custom settings. Using a tripod will help to ensure that you take sharp and blur-free still life photographs. As many of these images will be taken indoors or under modified lighting conditions, you may well find yourself using low shutter speeds for their capture. Using a tripod will ensure that the slow exposure setting will not affect the sharpness of the shot.

054 Tripods

Using a tripod will help to ensure that you take sharp, blur-free still life photographs. As many of these images will be taken indoors or under modified lighting conditions, you may well find yourself using low shutter speeds for their capture. Securing your camera on a tripod will ensure that the slow exposure setting will not affect the sharpness of the shot.

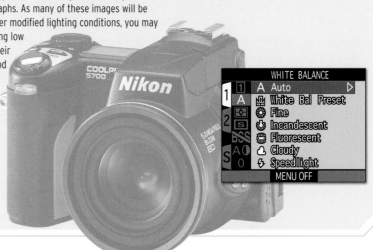

PHOTOSHOP AND THE STILL LIFE PHOTOGRAPHER

055 Explore White Balance in still lifes

Even with the advanced level of White Balance control available on most modern digital cameras there are times when your images will still be recorded with a dominant color cast. In the example below, the quality of the light was terrific and suited the picture, but as skylight is much bluer than daylight (and the camera's White Balance setting was set to daylight) the photograph contains a strong blue cast. For the best-quality color correction you need to remove such a cast when the file is still in its RAW state. Yes, this does mean that you need to photograph in the RAW format in the first place and then use the Photoshop or Photoshop Elements RAW editor, if you have it, to convert the file. The pay-off is more control and better quality from your cast-corrected pictures.

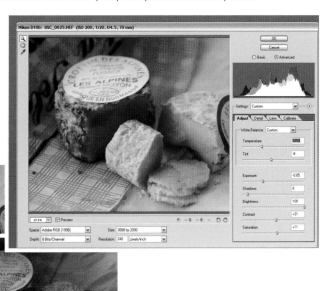

056 Practice your lighting skills

Build your understanding and ability to control lighting by practicing with a range of still life setups. Try single-surface objects to start with—for example, glass, gloss, silver, and textured—and then as your skills and confidence improve, challenge yourself by trying to light setups with multiple surface types.

057 Set up a makeshift studio

Set aside some time and space to practice your still life shooting skills by converting one of your rooms for a week into a simple photography studio. Having a suitable space to photograph will improve your abilities no end.

058 Use your new lighting skills outdoors

The lighting guidelines detailed here for shooting different surfaces work just as effectively outdoors as they do in the studio. Make sure that you incorporate these approaches when shooting in the field.

059 Keep lighting setup notes

It sounds a bit like overkill, but keeping notes on your lighting exploits, especially ones that detail the setup you used for different subject surfaces, will help you repeat successful lighting schemes. In addition, such notes will help diagnose problems with lighting scenarios that have not worked out so well. Include light quality and position as well as the placing of reflectors. Also jot down aperture, shutter speed, and White Balance settings.

Black and White

Although some digital cameras still have an option to shoot in black and white (grayscale), this mode has generally been removed from the features list of many models. Consequently, most photographers, no matter how in love with monochrome images and printing they might be, shoot color all the time. They convert their pictures to black, white, and gray after capture with the aid of their favorite software. However, shooting great monochrome pictures is quite a different art to the act of capturing wonderful color photographs. The following tips will show you how best to shoot color when you have monochrome in mind.

060 Light for grayscale

Color images that rely for strength on the quality of the light in the image work best for grayscale conversions.

062 Focus on composition

Be sure that composition in any pictures that you convert to grayscale is based on non-color based design ideas such as form, pattern, tone, or, in this case, line.

061 Watch your tones

Subjects based on two colors of similar tone do not translate to grayscale images with the same drama as the original.

063 Always shoot in color

Even if your camera has the option of shooting grayscale, you should always capture in glorious color. This approach will never limit your options. The same picture can be processed as a color photograph or skillfully converted to a series of grays and spend its life as a rich, velvety monochrome print.

064 Use light well

The strength of this monochrome image is drawn from its use of strong, direct light. Pictures that contain subjects that have little contrast in themselves need to be strongly lit to ensure dramatic results.

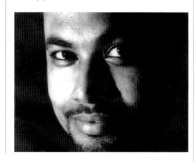

When a subject contains good contrast, softer, more diffused lighting will still produce good monochrome results.

065 Capture in the RAW!

RAW file-capture together with the options in the RAW file editor in Photoshop provides the best-quality image, which can then be used as a starting point for grayscale conversion.

066 Photoshop is your friend

Texture that is reminiscent of the grain of old, fast, black-and-white films can be added to your digital files using the various texture filters in Photoshop, such as Noise. (See Photoshop for Monochrome Shooters, technique 1 for more details.)

067 Edit in 16-bit mode

Ensure the best monochrome pictures by readjusting the contrast and brightness of the tones in the picture after conversion. For best results, these tweaks should be undertaken with the image in 16-bit mode. (See Photoshop for Monochrome Shooters, technique 2 for more details.)

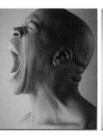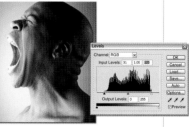

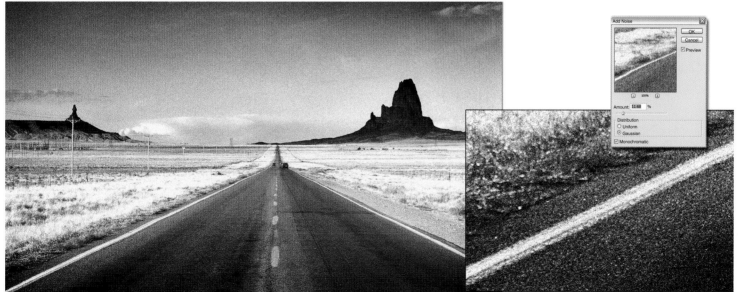

MONOCHROME PRINTING OPTIONS

With the editing and enhancement complete, it is now time to output the file. Making great monochrome prints involves three separate but equally important components: paper, ink set, and printer. When it comes to making your own prints, time spent in consideration and testing of print options will pay dividends in terms of the quality of your output.

068 Choose the right paper

There is now a huge range of papers and inks suitable for use in desktop printers. The combination you choose will determine the look and feel of your prints. Surface, weight, and base tint should all be carefully considered. The papers supplied by your printer manufacturer provide the easiest way to obtain predictable and reliable quality output. Their surfaces are often specially designed to work in conjunction with the inks themselves to ensure the best balance of archival stability, image quality, and cast-free monochrome prints.

When printing monochrome pictures, most ink-jet and bubblejet printers create the illusion of a series of grays by evenly cyan, yellow, and magenta dyes.

Advanced photographic printers like the Epson 2100 use an extra black (gray) to create neutral, cast-free monochrome prints.

069 Consider your ink set options

Explore the options for inks to make your prints. The cartridges supplied and recommended by your printer's manufacturer are specifically designed to work in conjunction with your machinery. These ink sets provide the quickest way to get great photorealistic images. But there are also several specialist ink companies on the market. Each provides slightly different pigments, which, in turn, produce images of different character. Only experiment if you see fine-tuning as a worthwhile challenge.

070 Explore black-and-white inks

Consider third-party ink set suppliers. Among them are a couple of companies that manufacture highly specialized inks for the dedicated black-and-white ink-jet enthusiast. Four intensities of black are substituted for the normal cyan, magenta, yellow, and black inks. With some simple image adjustments in Photoshop, it is possible to produce black and white images with tonal graduation that matches traditional silver halide printing.

071 Research ICC-enabled printers

Read up on ICC printing profiles. The standard desktop ink-jet can struggle to produce a neutral, cast-free, black-and-white print. This is due mainly to the fact that the lighter and midtone values are created with a mixture of cyan, magenta, and yellow dyes. Get the mix wrong and you'll end up with a tinge of green or blue. This is one of the reasons for using a fully color-managed system, original manufacturers' inks and paper, and the ICC printing profile that the printing company supplies. It accounts for the paper and ink characteristics, helping to produce neutral tones from black to white.

072 Consider printers with extra tanks

Some more advanced printers designed specifically for photographic output get around the "stray colors in monochrome prints" problem by adding another ink tank to the machine. The tanks usually contain a neutral gray ink along with the standard black and are designed specifically to be used to help create more neutral grayscale images. Dedicated monochrome enthusiasts may find purchasing one of these specialized photographic printers a worthwhile investment.

EQUIPMENT FOR BLACK-AND-WHITE PHOTOGRAPHY

073 Select a RAW- or 16-bit TIFF-enabled camera

Check to see what is the highest quality setting for your camera and scanner gear. Use RAW where it is available. Failing that, trawl through the manual for the possibility of using a 16-bit TIFF file format.

074 Maintain careful exposure control

Though not strictly gear-related, the impact of quality exposure on the production of high-class monochrome prints cannot be overstated. Slight under- or overexposure may be tolerable, but go a little further away from the optimal exposure and you will quickly find you will lose details in your shadow or highlight areas.

075 Matched paper and ink set

Reduce the possibility of creating cast-ridden black and white prints by using matched paper and ink sets along with the ICC profile created for the media.

PHOTOSHOP FOR MONOCHROME SHOOTERS

076 Adding grain

Despite the fact that most of the time we aim for grain-free versions of the scene that we see through our viewfinders, many photographers are still in love with the textured, gritty look that characterizes many high-speed films. In an attempt to recapture some of the atmosphere of such images, shooters are adding grain back into their pictures. Photoshop has at least three different ways that you can put the old-time texture into your monochrome prints.

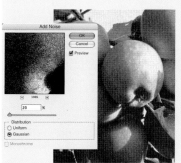

077 Texture technique 1: Add Noise filter

The simplest method is to employ the Add Noise filter (Filter > Noise > Add Noise). For black-and-white pictures, ensure that you have the Monochromatic option selected and that you are viewing the picture at 100 percent. Then adjust the amount and distribution settings to suit.

078 Texture technique 2: Grain filter

The Grain filter (Filter > Texture > Grain) provides a greater level of control over the range of grain types you can apply. With this feature you not only control the strength of the effect, via the Intensity slider, but the contrast also. The Grain Types menu provides texture options far beyond the standard film-grain look.

079 Texture technique 3: the Texturizer

The third technique makes use of Photoshop's Texturizer feature (Filter > Texture > Texturizer). This filter creates the look of surface texture in your image. You have the ability to add sandstone, canvas, burlap, and brick surface treatments and to alter the look and feel of the effect with the scaling and relief sliders. If this isn't enough choice, you can load your own textures (as PSD-format pictures).

080 Pegging white and black points

One of the most important enhancement steps in monochrome images is the allocation of black and white points in the tonal range. Often the conversion process from color to grayscale can result in lackluster images. Using a preview-based tool, such as Levels, you can reassign the black and white points to ensure that your shot contains crisp, white highlights and rich blacks.

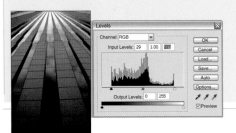

Children and pets
Though often considered some of the most difficult subjects, taking great pictures of children and pets provides tremendous rewards for the photographer. In the following tips, we list the dos and don'ts and give you the inside story on how to take great shots while keeping your cool.

081 Get creative

Taking candid pictures of your children on vacation gives you the advantage of them being in a good mood—well, hopefully! This means you can get more creative with some character-filled shots. Notice the shallow depth of field in this image. This is the result of a combination of a long lens (105mm) and a small aperture (f/4.5).

082 Plan ahead

Having as many of the technical considerations as possible worked out before you start shooting will mean that you can concentrate on shooting. Rather than directing the subject, which can often lead to stiff or stilted poses, allow the sitter to move freely within an environment that has a suitable background and props.

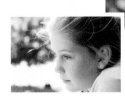
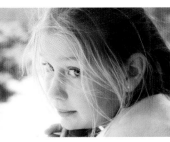
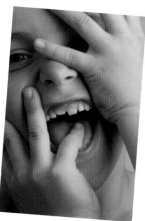

083 Shoot candidly

By shooting candidly, you can capture the special moments that show the character of the subject rather than just the likeness. This approach is perfect for digital, as it requires you to shoot many images keeping your eye on the subject and then reviewing your progress as you go.

084 Move with the subject

Try to move with the subject, taking images at the appropriate moment. Some interaction can also help bring about candid reactions. In the case of pets, make sure that the owner or handler stands close to you, so that when you want to get the animal's attention the owner can softly call the pet's name or dangle their favorite treat. Your job is to stay alert, keeping the subject focused and yourself ready to trip the shutter at the right moment.

Shooting a sequence of images can often provide more of an overall idea of a pet's behavior, especially if they are situated in a natural environment.

[Images courtesy of www.ablestock.com.]

085 Add a prop

Another way to add a sense of character to a portrait is to ensure that any props or background used are consistent with the sitter's personality. If the child loves soccer, then why not include his or her favorite boots in the foreground (still muddy) and a distant photograph of his or her team on the wall at the back. These will add to the storytelling aspect of the picture.

WORKING AROUND PROBLEM ENVIRONMENTS

In the first few tips, I have advocated a candid approach to photographing. Shooting this way means that the photographer continues to photograph while the subject moves freely within a chosen environment. The downside of the approach is that many of the images captured can have distracting backgrounds or inappropriate objects elsewhere in the frame. There are two different ways to solve this problem.

086 See the whole frame

Scan the whole of the viewfinder (foreground, midground, and background) looking out for distractions. When they appear, either change your angle of view or wait till the subject is better positioned. If neither of these two options is available, try using a shallow depth of field so your subject stays sharp but the background is blurred out.

087 Move in closer

Being close to a subject will also help to create a shallow depth of field effect.

Getting in close helps to isolate the subject from the background and capture great expressions like this one. Close-ups require very good focus control and an aperture and shutter speed combination that both freezes movement and provides the necessary depth of field. [Image courtesy of www.ablestock.com.]

088 Set up the background and props

When you have a little more control over the environment, try to minimize distractions by simplifying the background, removing inappropriate objects, and adding useful props. This way the subject can move freely in the environment and you will know that whatever enters your field of vision will be appropriate.

089 Use a long lens

Lens lengths longer than 50mm (on a 35mm camera) will help create a shallow depth-of-field effect. In low-light situations, be sure to use a tripod to help stabilize the camera when using longer focal lengths.

GREAT PORTRAIT LIGHTING

Lighting (and exposure) can really make or break a portrait and as the subjects for most child and animal photography are always on the move, the task is made even more difficult.

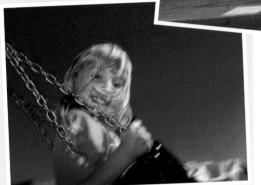

When photographing outside, especially on sunny days, it is almost impossible to escape deep shadows falling across the subject's face. A good way to continue shooting even in these tricky conditions is to use a twinkle of light from your camera's built-in flash to lighten the shadows.

090 Getting your exposure right

Check the exposure in several places in the environment (using a substitute sitter) before your subject arrives. Ensure that you have enough light to make a good exposure and that the quality (soft and diffused, or hard and contrasty) suits the subject you are working with. If possible, adjust the lighting so that there is a broad area where you can use the same exposure settings. Remember these settings and mark on the ground the extent of area that has consistent lighting. As long as your subject stays within the boundaries of this area, you can be sure of good exposure and good lighting.

091 Up the ISO

For this type of work, a higher ISO setting than normal (perhaps 400 or 800) will provide a greater range of aperture choices.

092 Pre-arrange lighting

Consider pre-arranging the lighting. Try pulling back the drapes from a bay window and hanging a white sheet on the opposite wall to act as a big reflector, or reflecting the light from a portable flash unit off a piece of white card positioned to the side of the camera.

COMPOSITION AND POSES

Although at the start of this section, I tried to steer you away from a formal approach to photographing children and pets, there is still some merit in learning from, and applying, some of the golden rules of formal posing in your candid shooting work. It is true also that pictures involving several subjects, or taken while on a family trip, can benefit from a little careful direction.

093 Arrange the spacing

When standing or sitting in a group, there is a natural and comfortable space that we place between ourselves and others. The space is larger if we are with strangers and closer and more intimate with friends and family members. Though comfortable to us, the size of this space can be visually too large in photographs of two or three people. Encourage your sitters to move closer together.

094 Stagger the focal points

Positioning all your subjects in a row of the same height might work for military parades, but it generally doesn't look good for most other subjects. Try to arrange your subjects so that they are positioned at different heights within the frame.

Lighting problem-solver

Lighting problem	Solution
Images blurry from camera shake	When shooting inside using available light you will need to increase your ISO setting to ensure that you are using a fast enough shutter speed to freeze the action
Deep shadows under the eyes	When photographing in full sun use a reflector or fill-flash to throw light into the shadows areas of the picture
Subject appears as a silhouette	When the light is coming from behind the subject be sure to add an extra stop of light to that determined by the exposure system by using the camera's exposure compensation feature

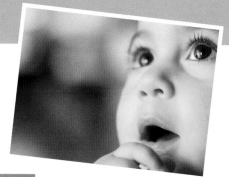

095 The rule of thirds

Don't forget compositional tricks such as placing the focal point(s) in the frame using the rule of thirds (either a third down or a third up from the edge of the frame, or a third in from right or left).

096 Watch eyes, hands, and feet

Watch eyes, paws, and tails in your pet photography, and hands and feet in human portraits. The correct positioning of these elements can make or break a shot. If you are directing it, check that the eyes are looking in the right direction—and are open, of course.

097 Practice makes perfect

"The more you shoot, the better you get" is probably the best advice I was given as a young photographer. When working with children and animals, this adage is probably truer than with other subject areas. There is no substitute for time spent practicing, so get out there and start making some great pictures that capture the real life of your subjects.

EQUIPMENT FOR PHOTOGRAPHING CHILDREN AND PETS

Having the right gear to hand can increase your chances of success when photographing these tricky subjects. The following pieces of equipment are the essentials that should always be included in your kitbag.

098 Long or telephoto lenses

Lenses longer than 50mm (on a 35mm camera) are best for portrait work. They allow the photographer to fill the frame without being so close to the subject that the sitter feels intimidated. Typically, focal lengths of 85 to 150mm are used for portraits.

099 Reflectors

A large reflector, such as a white sheet, can be used to help reflect windowlight into a room. Smaller, portable reflectors, made from white card, are good for lightening shadows in contrasty sunlight, or can be used as a bounce board for a portable flash unit. Experiment with getting your subject to hold one (out of frame).

100 Tripod/monopod

Photographing indoors, even with a high ISO, can sometimes call for low shutter speeds, so a tripod or even a monopod can be very useful to ensure sharp pictures.

This distant subject was pulled into focus using a telephoto lens.

101 High ISO setting

Though not strictly a piece of equipment, it is worth mentioning that the ability of your camera to be set to a high ISO value such as a setting of 400 or 800 will give you more options when shooting under existing light conditions.

102 Portable flash unit

A portable flash unit can be employed to lighten shadows when shooting outdoors, or help provide extra illumination when you are working inside.

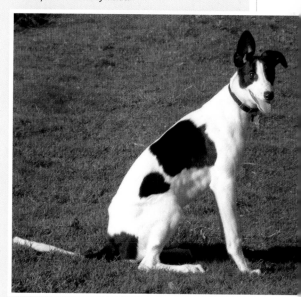

PHOTOSHOP AND THE CHILD AND PET PHOTOGRAPHER

Even the best planning can leave you with photographic results that are not quite what you had desired or even expected.
Use the following photo-editing tips to help improve your pictures.

103 Improve on existing light

If you want to improve poorly lit but well-shot images, it is time to turn to Photoshop or Photoshop Elements. Their Dodging and Burning tools can help remedy some problematic lighting situations. Here the Dodge tool is used to lighten the sitter, while the Burn tool darkens the background.

• **Step 1:** With the image open, select the Dodge tool. Choose a large soft-edged brush. Set the range of the tool to Midtones and the exposure to approximately 20 percent. Stroke the darkened foreground with a series of slightly overlapping strokes. Be sure to keep within the shape of the subject. Don't overdo it!

• **Step 2:** Now switch to the Burn tool. Again, work with the midtone range and an exposure of 20 percent. Stroke the light areas in the background to darken. For the brightest parts, select the highlight setting for the range and reduce the exposure to below 10 percent. Carefully stroke the lightest background areas and make sure not to overdo the effect.

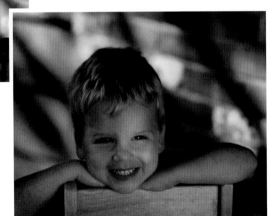

104 Minimizing distracting details

Most image-editing packages contain at least one tool to remove or disguise unwanted elements in a picture. The Clone (or Rubber Stamp) tool (among others) in Photoshop and Photoshop Elements can be used to sample background details and paint the same tone and texture over the distracting part of the picture.

In the example image, we wanted to remove the blurry subject on the right with the Clone tool.

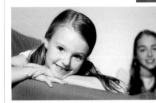
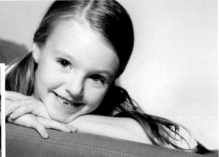

• **Step 1:** With the image open, select the Clone tool from the toolbar. Choose a soft-edged brush. Make sure that the mode is set to normal and the opacity and flow values to 100 percent. Start the process by selecting the area to sample. Do this by holding down the Alt key and clicking on a clear area of the background.

• **Step 2:** Now release the Alt key and move the cursor over the area to be painted over. Click and drag the cursor to paint over the existing pixels with those of the sampled area. For more intricate areas, use a smaller brush size. Always be careful to match the tone, texture, and color of the new areas with the rest of the scene.

105 Other useful Photoshop tools

Photoshop has a range of tools that can be used for object removal. The Healing brush, Spot Healing brush, and Patch tools both extend the "sample and paint" approach to include a more seamless integration with surrounding pixels.

PHOTOSHOP TOOLS

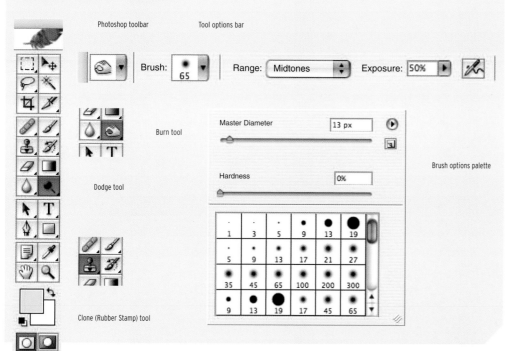

Photoshop toolbar

Tool options bar

Brush: 65

Range: Midtones

Exposure: 50%

Burn tool

Master Diameter 13 px

Hardness 0%

Brush options palette

1	3	5	9	13	19
5	9	13	17	21	27
35	45	65	100	200	300
9	13	19	17	45	65

Dodge tool

Clone (Rubber Stamp) tool

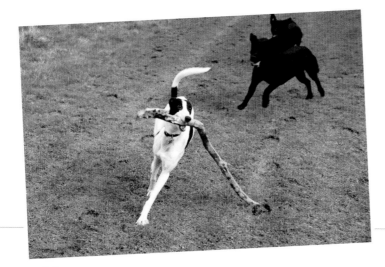

106 Organize technical details first

Technical considerations like aperture, shutter speed, lighting, and overall exposure can distract you from your mission, so make sure that as many of these as possible are organized beforehand. This will leave you free to work with your subject.

107 Shoot lots of pictures

The great bonus of digital shooting is that it doesn't cost you any more to photograph lots of images. This is great for difficult photographic subjects such as pets and children. Shooting many pictures will help to make up for the unpredictable nature of the subject. A few terrific shots is all you need from a single session.

108 Check your results

When working quickly, it is often difficult to account for changes in lighting conditions. Use the digital camera's LCD monitor to review these tricky shots and check your results. When problems arise, make your changes and then reshoot. This is a great way to improve your work.

109 Involve the subject in an activity

Giving your subject their favorite plaything (doll, rubber bone, GameBoy) or encouraging them to undertake an activity that they enjoy (finger painting, dancing, chasing a ball) will provide you with great photo opportunities. The subject will be less self-conscious, the images less staged, and the poses less awkward when working this way.

Bad weather and winter shooting ideas It's easy to think

of photography as being a summer activity, or something we only do in perfect weather, but the reality is that we take pictures all year round, and often in less-than-ideal conditions!

110 Be careful when exposing winter scenes

Light meters in cameras are designed to provide exposure settings that will record all the subjects in a scene averaged to a theoretical mid-gray. This is fine for most photos, but the approach will prove disastrous if used to photograph a snow scene. When taking photographs that are predominantly white, be sure to use the camera's exposure compensation feature. Keep previewing and adjust the control by a stop or two until the snow is recorded as a crisp white rather than a murky gray.

111 Take plenty of batteries

Very cold weather will take its toll on the performance of the batteries that are critical for the functioning of your digital camera. Cells that provide hundreds of shots in warm weather drastically lose their power if the temperature plummets below freezing, so make sure that you have fully recharged your batteries. Have extras to hand just in case.

112 Don't overcorrect low-contrast pictures

It is tempting to spread the tones of gloomy, gray, winter pictures so that both shadows and highlights are mapped to pure black and white. After all, this is precisely what you have been told to do for years. But there are some occasions when the mood of the picture requires a more sympathetic approach. Applying too much contrast and brightness correction will lose much of the feeling in the picture. So what are the alternatives?

Option 1: Remapping shadows to black, and highlights to white, is usually performed by dragging the white and black input sliders in the Levels dialog towards the center of the graph. Instead of doing this, try lightening the image by dragging the midtone input slider to the left of the graph. This makes the picture brighter without altering the overall contrast.

Option 2: A similar change to the brightness of the photograph can be made using the Curves feature. Simply click on the center of the sloping line and drag it upwards—again lightening the picture occurs without altering the overall contrast.

Option 3: In the final option, let's increase the midtone contrast only giving the picture a little more zap but without remapping the black and white points. Do this by moving the Midtone Contrast slider of the Shadow/Highlight feature to the left.

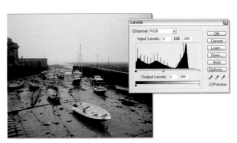

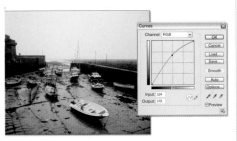

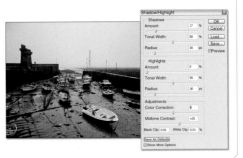

113 Watch for condensation build-up on equipment

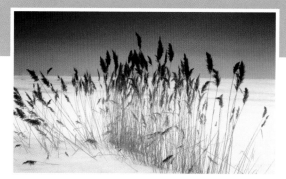

Moving from the cold outside to the warmth of a centrally heated building can play havoc with your camera and other photographic equipment. The sudden change in conditions can cause condensation to build up on the glass surfaces of lenses and viewfinders. Protect your camera by wrapping it in a plastic bag before entering a warm environment. Only take it out once it has warmed up to the temperature inside. If you do see condensation on the camera, remove the batteries and memory cards, leaving the compartments open to allow them to dry out. Don't take a camera with condensation out into the cold as it may freeze.

114 Manual focus in low-contrast conditions

Autofocus systems work best when pointed at contrasty subjects, which can make accurate focusing in winter a little tricky. This is especially true when all around seems gray and even the lighting is subdued. If you find your camera's lens constantly whirring in its mission to focus on the scene, try switching to manual focus to ensure that your subject is crisply recorded.

115 Try capturing subjects like reflections or shadows

The lack of traditional shooting subjects in winter time, such as brightly lit landscapes and lush green trees with flowering undergrowth, provides the opportunity to try your hand at something different. So instead of photographing specific subjects directly, try pointing your camera at the things that reveal their presence in other ways, such as shadows and reflections. Try shooting the reflection of a building in a puddle, or the play of light on a sheet of ice. Shoot the shadows of objects or people.

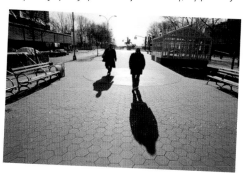

116 Go with the atmosphere, don't try to recreate summer

As we are only too aware, cold winter light, or a landscape on a bleak, late autumn day are very different to the balmy atmosphere of midsummer, and yet many of us insist on bringing our summer-filled expectations along when photographing other seasons. Don't try to recreate or capture pictures with a summer feel. Look for and record the essence of the season. Try to capture the atmosphere and ambience of the cooler, darker months.

117 Use Noise Reduction for longer exposures

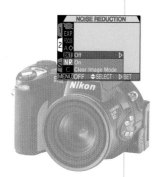

The low lighting conditions of the winter months mean longer exposure times. When using exposures greater than one second you will start to find that your digital photographs start to look a bit noisier than normal. To get smoother long-exposure photographs make sure that your camera's Noise Reduction feature is switched on.

118 Remember your compositional skills

Great images are made when time is spent composing the various elements in the scene, and dialling the right settings to capture the moment. This is no less true when shooting in the cooler months. In fact, given the often-subdued colors and soft lighting of wintertime, the importance of good technique becomes even greater. Use this time of the year as a chance to hone your eye and to understand different aperture and exposure settings. Preview as you go.

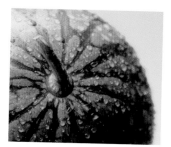

119 Use the winter to practice indoor lighting and shooting

Why not use the days when night comes quickly to firm up on your indoor shooting skills? Buy, borrow, or hire a basic light system and set yourself a goal of learning how to use it. Try shooting portraits, capturing still lifes, and making macro pictures.

120 Use snow feet for your tripod

Pointy or rubber-nosed tripod feet might be great for dry conditions, but they don't provide the stability you need when shooting on snow. Companies like Manfrotto sell special snowshoes that are designed to solve this problem.

121 Use a waterproof camera bag

Pack your kit away in a camera bag that is waterproof (or at least water resistant). This way you will be prepared if the weather turns bad. Lowepro makes an all-weather range of bags.

122 Try motion blur

Set your camera to slower than normal shutter speeds (less than 1/15th second) and photograph a range of moving subjects to create a series of blurred motion pictures.

123 Be spontaneous!

Force yourself to shoot outside of your comfort zone. Don't restrict yourself or pre-empt the results, just fire away, and review and edit your results later on the desktop.

124 Try framing the same scene in at least 10 different ways

Stuck for subjects to shoot? Use the winter landscape to exercise your framing skills by selecting a single location and attempting to photograph it in 10 different ways. Try vertical, horizontal, symmetrical, asymmetrical, golden mean composition, low angle, high angle, in close, from a distance, panoramic, shallow depth of field, extreme depth of field, steepened and flattened perspectives.

125 Protect yourself and your gear

It might seem obvious, but take as much care with your own attire as you do ensuring that your camera is well protected. Having frozen hands when using tiny camera controls, or having the shivers causing camera-shake on long exposures are not recipes for capturing the beauty of a winter's day!

126 Shoot RAW for best highlights and shadows

Never tried out the RAW file capture function on your camera? Winter is a great time to experiment. Shoot a series of pictures in RAW and varying JPEG modes, comparing the results. Take particular notice of how the powerful RAW option does a great job of maintaining detail in the shadow and highlight areas of even the most difficult shooting scenarios.

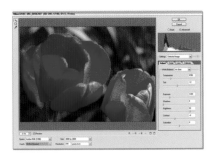

127 Practice your editing and enhancement skills

The long nights are a great time to explore your favorite editing software and to acquire some new skills at the same time. Why not try to get a handle on Adjustment Layers, Channels, Masks, Unsharp Masking, or a lens blur filter? You know that you have been promising yourself that you would when you could find the time!

128 Take extra care when printing so that delicate highlights are not lost

It is quite easy to lose subtle highlight details when making prints of your winter photographs. Understanding how your printer, inks, and paper work together will help you retain these delicate details in the final print.

• Step 1: Start by making a grayscale that ranges in discrete steps from 225 (light gray) to 255 (pure white). Make sure that you indicate where one tone stops and the next starts, and its value.

• Step 2: Now set your printer on the typical settings that you will use to output your photographs. Write down these settings. Print the test grayscale and let the print dry. Now carefully examine the print and locate the exact point where there is no difference between the printed areas and the paper. Note down the tone value at this point.

• Step 3: After making basic brightness and contrast changes to your picture you can customize it to output precisely on your printer by adding a Levels Adjustment Layer as a last step before printing. Drag the white point Output slider of this layer until it matches the tonal value you wrote down in step 2. Now you can be sure that your highlight details will print within the range made possible by your hardware.

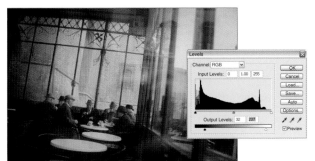

129 Don't change batteries, cards, or lenses outside

Just like when you are shooting at the beach or in a dusty environment, it is unwise to change memory cards, batteries, or lenses when outside in winter or fall weather. Doing so could introduce moisture or dirt into the camera and cause problems that are expensive—perhaps impossible—to repair. If you are forced to change cards in the field, always use your body and coat as a shield to protect against dirt and dust entering your equipment.

130 For something different try shooting weather

Why not turn the tables on the weather and make it the subject of your photographs? Concentrate your picture-making efforts on recording the wind, rain, snow, gloom, or fog.

131 Don't wait for the weather to improve!

If you wait for the weather to improve before you start shooting, you might waste thousands of great opportunities for taking great pictures. Great photos are waiting to be captured, no matter what the temperature is!

132 Set yourself a theme for your pictures

Can't get inspired? Try giving yourself a theme to shoot to, just like a professional photographer. Commission yourself to shoot a series of pictures centered on a single idea, or topic. This will get your creative juices flowing and provide you with some inspiring shooting opportunities.

133 Be prepared!

Think ahead and imagine a variety of weather and shooting scenarios that might present themselves, and then use your imaginings as a basis for preparing for your winter-day shooting. I'm not suggesting that you should weigh yourself down with the sort of provisions that Scott would have been proud of at the South Pole, but you will need to ensure that you plan for the worst case scenario.

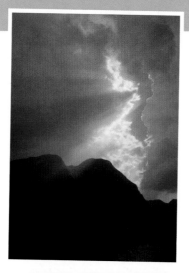

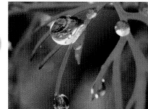

134 Use shallow depth of field to pick out important details

One way to add visual drama to a gloomy-weather photograph is to make creative use of those parts of the picture that are sharply focused and those that are recorded as blur. This technique is called creating a "shallow depth of field of sharpness."

Factor 1: The best-known way to create a shallow depth of field is to use a low aperture number to record the picture. Typically f-stop values of f1.4 to f.4.0 are used for this effect.

Factor 2: The second factor that determines depth of field is the length of your lens. Longer lenses automatically create images with shallower depth of field. Try using lenses with focal lengths longer than 180mm for best results.

Factor 3: The third way to create shallow focusing effects is to be close to your subject. In fact, the closer you are to the subject, the shallower your depth of field will be. This is why macro images have such a small depth of field.

135 Don't use Auto Correction tools for enhancement

Many of the autocorrection and enhancement tools in your favorite editing program treat all pictures in a similar way, irrespective of their content. Because images such as snow-covered mountains contain an unusual amount of lightly toned detail it is best to ignore features like Auto Color, Auto Levels, and Auto Contrast. Use Levels or Curves manually.

136 Take a couple of lens options to ensure good coverage

It is often easiest to walk out the door with a camera body coupled with a single lens. Doing so may make your load a little lighter but you can also be guaranteed to miss other photographic opportunities because you have left the remainder of your lenses at home.

137 Try your hand at still lifes

Decided to spend the cold months close to the heater? Don't let that stop you shooting. Take your phoography indoors by shooting a variety of still lifes. This long-respected area of photography takes time, patience, a good understanding of lighting, and great composition.

138 Turn your back on traditional subjects

We all get into a photographic rut, shooting the same subjects in the same way. After all, being in the comfort zone of our own abilities means that we can be sure to get some good pictures from each shoot we undertake. But not pushing the boundaries of your own skills will eventually cause your photography to stagnate. Get inspiration from style magazines.

141 Get to know your built-in flash unit: try a range of tasks

Winter is a good time to practice your flash photography, both indoors and out. Get to know the features of both your flash and camera as you practice using the equipment in a range of shooting scenarios. This way you can be assured of the results you can obtain with your equipment. Try out these techniques: red-eye reduction, fill-in flash, slow shutter plus flash, rear-curtain sync, and multiflash (strobe).

139 Catalog and backup your summer shooting exploits

This is not the most exciting job on the planet, but it is definitely one that should be done. Just ask yourself the question, "Would I be upset if my hard drive failed tomorrow and I lost the thousands of images I have stored on it?" If you answered "yes" then you should start to back up those precious pictures today. You can write them directly to CD or DVD, or use a backup program to transfer copies to an external drive. Perhaps explore the possibility of using an online storage service.

142 Start to restore those family heirlooms

Stop putting it off! Now is a good time to start restoring those crinkled and torn photographs of distant relatives that you have been promising to finish, but as yet haven't even managed to start. Practice using the Healing Brush or Clone (Rubber Stamp) tools while removing lines and dust marks and repairing torn edges. Carefully coax detail out of faded photographs with skillful use of Curves and Levels, and finally put back a sense of nostalgia by sepia-toning using the Hue/Saturation control (with Colorize selected).

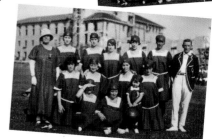

140 Put together a Web site of the pictures you have taken this year

Search through your archives and gather the best images that you have made over the last 12 months. Now use the Web Photo Gallery option (File > Automate > Web Photo Gallery) in Photoshop or Photoshop Elements to create your own online gallery. Upload the finished site to the Web and resolve that next year at the same time you will update it.

143 Practice shooting some local architectural landmarks

Take the opportunity of a quiet social season to have a go at some architectural photography. With wide angle lens and tripod in hand practice the skills of setting up, aligning, framing, and checking exposure and color balance before tripping the shutter. After editing and enhancing the best of the results present some high-quality documentary prints back to the owners or managers of the building.

143 Substitute alternative skies in drab winter landscapes

Rather than discarding winter pictures that have drab, gray skies, try cutting and pasting skies borrowed from other pictures. You can add the sky portion of the picture as an extra layer to the original and then use the Eraser to remove unwanted areas, or you can use the Paste Into command to place the new sky in the position of the old. Try using stormy skies as well as "sunny day" versions as replacements.

145 Photograph your friends and relatives

When you have friends and family over on long winter evenings, try out your portrait skills on them. Experiment with different lighting techniques, get your visitors to try different poses—both formal and informal. Preview the results on your computer and frame some enlarged prints as gifts.

146 Correcting winter color casts

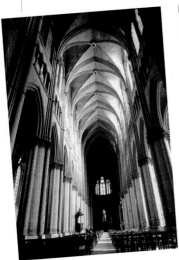

No matter how clever the color balance system in your camera is, it will never be able to neutralize two differently colored light sources in one photograph. Many winter interior photographs have this problem, with blue light coming through the windows and warm yellow hues inside the room. Correct the problem by selecting the window areas first and then neutralizing the area using Image > Adjustment > Color Balance. Next invert the selection (Select > Inverse) to isolate the inside of the room and apply color correction here as well.

147 Lose unwanted details in your images with the Healing Brush

Add strength to your pictures by simplifying their content. Lose unwanted details, such as the proverbial telegraph pole out of the top of your subject's head, with the help of features like Photoshop's Healing Brush, Rubber Stamp, or Patch tool.

148 Shoot for mood and not for detail

In filthy or gloomy weather forget about trying to photograph specific subjects, and instead concentrate on capturing the mood of the occasion. Record people's reactions to the environment. Picture them shielding themselves from the cold or holding an umbrella against the wind and rain. Show overall scenes such as windswept alleys or water-drenched roads. Let your pictures become a description of the mood of the day.

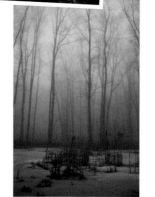

149 Saturate/Desaturate to change color contrast

We use the Dodge and Burn tools to help add tonal contrast to your pictures by darkening or lightening selected portions. Why not use the Sponge tool in Saturate and Desaturate modes to perform a similar function with the strength of the color in the photograph? Make the key areas of interest more saturated and tone down the vibrancy of those less significant elements.

150 Change your point of view

Many of us photograph from the same height for most of our photomaking lives. Why not try shooting from a different level to see what effect it will have on your pictures? Try to shoot for a day from a low angle or a high one.

151 Go shooting offshore

Change your photographic point of view by traveling. Take advantage of cheap internal flights or overseas city breaks. Often a change of place gives you new eyes as a photographer, and plenty of new ideas.

152 Take a series of photos to illustrate an emotion

Push your creativity to the limit by creating images that capture feelings of anger, joy, love, compassion, or grief with a single shot or a group of pictures. Think broadly when approaching the subject. Try brainstorming 20 different moods.

153 Crop for success

Make a copy of an image and use the Crop tool to add strength and interest to it by adjusting the shape or format. Use it to reposition the main subject in a different part of the frame—be radical with portraits and concentrate on an eye, or one side of the face. Pull out a detail and make it the subject.

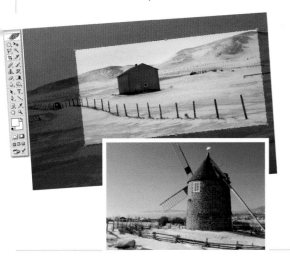

154 Add some digital sunlight by using an upside-down Unsharp Mask

Most readers will know the Unsharp Mask filter as a way to enhance the clarity of your pictures, but it can also be used to change the look of the contrast of the midtones in your pictures.

• Step 1: Open the Unsharp Mask filter and make sure that the preview checkbox is selected.

• Step 2: Drag the Radius slider about three quarters of the way to the right-hand end of the slider. This setting may need to be fine tuned after Step 3.

• Step 3: Now select the Amount slider and gradually move the control to the right watching the preview thumbnail and the changes in the larger image. You should see a big change in the midtones/ contrast.

155 Constructed realities

Search your archives for suitable pictures to use for creating a fantasy montage. Open the candidate photographs and drag each onto a single canvas. Use the Edit > Transform > Scale feature to adjust the size of the various montage parts. Next use the Eraser to remove sections of each layer to blend the parts together.

156 Shoot a "day in the life"

Take on the role of a documentary photographer and shoot a series of pictures that records the daily activities of one of your friends or relatives. Start early in the morning with pre-work events and then follow your subject through the day.

157 Create a wall calendar

Put your editing and enhancement skills to work by producing a calendar featuring 12 months' worth of pictures of the kids, for example, to be given as presents. If you've no kids or pets to include then why not make a seasonal calendar featuring your own great pictures?

Grabbing stills from digital video

Many digital stills cameras come equipped with a Video mode that allows you to capture short movie clips. Although these cameras don't offer the quality of dedicated video cameras, they still produce movies that contain enough detail for most of us to enjoy. From time to time, you might want to turn those details into images in their own right. You can do this by grabbing frames from the video footage with your favorite image-editing program, such as Photoshop Elements and its "Import frame from video" feature.

158 Check video format

Check to see that the video files that your camera records (.mov, .avi, etc) are in a format that the software program can read. Open the feature and check the acceptable file types in the browse or open file dialogs.

159 Use a conversion program

If your camera's video format isn't supported by your software and you can't adjust your camera settings, you need to convert the file format using a conversion program. There are many free utilities on the Internet. Just search under the relevant formats, such as "AVI to MOV convertor."

160 Make your own title sequences

Grabbed frames from videos make great backgrounds for slideshows and home movie productions. The low resolution of most still video frames makes them perfect for screen-based presentations. To create your own title slides, open the image in an editing program, create a feathered selection of a portion of the picture, and then brighten the area using either a Brightness/Contrast control, or a Levels feature. Finally, add some text in a contrasting color and save the file into the library folder that you use for the elements of your video production.

161 Search for your frame

Using the VCR buttons (play, forward, reverse, stop, and pause) in the Feature dialog, play the video to locate the sections that contain images you want. Click the Grab button to capture the video frame as a still image and then pass it to the Elements workspace. Alternatively, you can use the slider control to move through the video sequence.

162 Match the size with the job

As the resolution of most video frames is relatively low, use your newly grabbed images in a montaged form when printing. This way, you can build up the total size of the document, allowing you to print much larger photos than would normally be possible if a single frame were printed by itself.

163 Reduce the fuzzies!

Captured stills from video often look poor in quality when first viewed onscreen. One reason for these fuzzy images is the way that they are captured and stored. Most cameras record every second line of the picture for each frame. The quality of these types of frames can be improved by using the De-interlace filter (Photoshop/Photoshop Elements > Filter > Video > De-interlace), which adds extra information to the picture to fill the vacant spaces. Several different approaches are available. Try each of the settings to see which works best with your pictures.

164 How big can you print?

The second quality issue affecting grabbed frames is the small capture resolution: 320 x 240 pixels is typical. To check the size that your grabbed frames will print, use the Image Size feature in your editing software. In Photoshop Elements, select Image > Resize > Image Size and, with the Resample Image setting off, input your print resolution. Here, we've used a standard photo-quality setting of 200 dots per inch (dpi), resulting in a print of 1.6 x 1.2in.

165 Increasing picture size

If you are dying to print your video grabs individually and you are not happy with the small size they output at, use the resizing options in your image-editing program to upscale or enlarge the frame before printing. The final results will not be as sharp as a digital photo captured at the same resolution.

 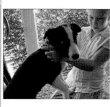

166 Combine to print bigger

Alternatively, you can create a new, larger composition that is made up of several of the video grabs montaged together.

167 Movie mode = restricted features

On many camera models selecting the Movie mode restricts the features that are available when shooting. These may include turning off Autoexposure and Autofocus. With this in mind, it is always a good idea to set focus and exposure before starting to video the scene. Check your camera's manual for a detailed list of feature restrictions.

168 Use a big memory card for movies

The minimovies captured by digital still cameras eat up memory card space very quickly. Check to see the film time available for the card that you currently use and buy a larger card if you take video regularly. Remember that your still photos and video share the card space, so keep a little space in reserve.

Groups

Group portraits take all the challenges of individual portraits and multiply them many times over. So here are some handy hints, tips, and techniques for taking strong and dynamic group shots that work as great photographs rather than simply as uninspiring records of a (perhaps once-in-a-lifetime) gathering.

169 Compose the people in your pictures

One of the foundations of great group shots is good composition. Working with several subjects means that you will have to think beyond the "stick the person in the middle of the frame" approach. The relationship between individuals is vital.

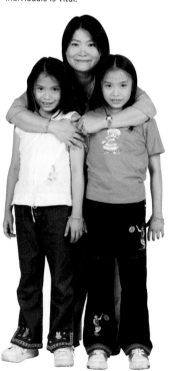

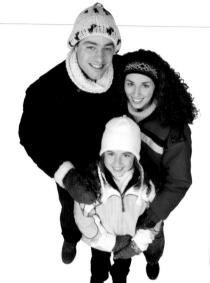

170 Try this angle!

Try to arrange your groups so that they make use of the "triangle of strength" rule to balance the picture, placing the heads of each subject in a triangle shape within the frame. This will produce a very strong composition.

171 Fill the frame

Whether you are involved in the positioning of each person, or if you are simply capturing a candid scene, the subjects should fill the frame, overlap (but not so much that you don't see their faces), and be looking at the camera or at each other. Be assertive to make it work.

172 Crop close and stand even closer

When standing casually, most people respect each other's personal space. We tend not to cross into these spaces even when we are being grouped together for a photograph, with the result that large gaps can appear. Work with your portrait sitters to make them feel comfortable enough to move close together. Pros encourage participation by maintaining eye contact with their subjects and talking them through the arrangement process. Keep checking your setup through the viewfinder to be sure that there are no awkward vacant spaces. For couples, try overlapping shoulders and, for larger groups, move shorter people to the front.

173 Minimize and overlap

Make sure that any detail in the background adds to the "story," and set the aperture to ensure that the viewer's attention stays on the main subject.

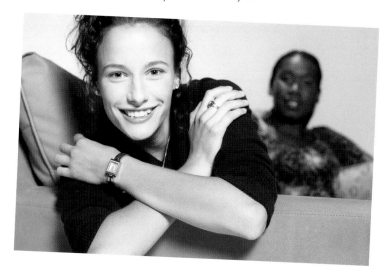

174 Reduce distracting backgrounds

Remember the photographic golden rule that great photographs are made when foreground, midground, and background all work together to enhance the subject. This advice remains true for group photographs. Don't concentrate on your subjects so much that you miss distracting details around your sitters. Minimize these problems either by moving your group to a better location, moving yourself around the action to capture different backgrounds, or using a smaller f-stop number to drop the background out of focus.

175 Move to find the best lighting

Unless you are lucky enough to have a studio at your disposal, most of your group photographs will be taken using available light. Be conscious of the quality and direction of the light and, if need be, move your group so that it is closer to or angled toward the light source.

176 Try out fill flash

If you are at the mercy of the weather, or the artificial light in a reception venue, this may be a good opportunity to add to or modify the existing light with a little fill flash. Most digital cameras have very sophisticated built-in speed lights. Modern exposure systems can easily handle balancing the flash output with the available light. When used carefully, this way of working can provide good results even in the trickiest situations.

177 Candid or formal?

Formal occasions demand formal photographs... or do they? Weddings, for example, often see a plethora of standard "bride and groom," or "bride and groom and his parents" pictures. Photographers are heard saying, "feet together, hands in the front, left over right, right shoulder forward." The end result is highly formalized group photos. These are fine for an overall record of the occasion, but these events are also great opportunities to photograph people interacting candidly. Take the time to look at the action behind the formal setups. This is where you will find candid pictures–natural, rather than directed.

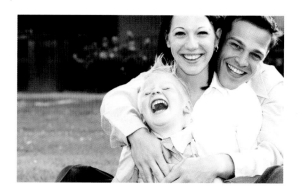

Close-up shooting

Close-up photography has a long and celebrated tradition. However, in the days when film was king, following a passion for macro often meant having to buy specialized lenses, filters, or attachments. One handy but often overlooked feature of modern digital cameras is their ability to get in close. Most new models have more than respectable macro functions built in as standard, and some even have minimum shooting distances as little as half an inch (1cm).

178 Check your camera's macro abilities

If you are interested in shooting macro images and are planning to buy a new camera or upgrading from an existing model, check the specifications on your existing model before spending any more money. Look at values for the minimum focusing distance; this will give you a good indication of the camera's macro abilities. Also check to see if this distance is the same throughout the whole of the zoom range. A camera that has a minimum focusing distance at its longest focal length will usually get you closer than one with a macro function that works with the wide-angle portion of the zoom. Use the specifications as a guide to narrow down your choice of models.

Macro images provide detailed pictures of scenes and subjects that might otherwise go unnoticed.

179 Intricacies of close-up shooting

Shooting a macro image is essentially a photographic exercise just like any other. All the standard imaging concerns such as composition, exposure, focus, camera movement, and white balance apply. But unlike other shooting tasks, extra care has to be taken because of the proximity of the camera to the subject and the degree of magnification of the image. Small errors in focus become very obvious in macro images. In a similar way, even the slightest camera movement will ruin a perfectly composed closeup shot. As much of this style of photography is concerned with filling the frame with a single subject, the Autoexposure and Auto White Balance features may produce less than perfect results.

IMPORTANT TIPS WHEN CAPTURING MACRO PHOTOGRAPHS

180 Set your focus

Macro close-up

Focus is critical for all close-up work. Be sure to select the Macro mode when moving the camera close to subjects.

After establishing the composition of your image, the next task is to set your focus. This can be accomplished manually by measuring the distance from camera to subject, switching the camera to manual focus, and then adjusting the lens. Alternatively, most cameras have a special Autofocus Macro mode. This feature sets the camera to search for the sharpest focus at closer subject-to-camera distances. With either method, confirm your settings by taking a couple of test shots, switching the camera to Play mode, and using the Enlarge or Zoom feature to check for sharpness.

181 Adjust depth of field

Depth of field is particularly important when capturing macro images, as one of the main factors that control the depth of field in a picture is the distance between the subject and the camera. The smaller this distance, the shallower the depth of field. As most close-up shots require the camera to be very close to the subject, there is usually very little depth of field in the pictures. To increase those parts of the image that are sharp, the macro shooter will need to use another depth of field factor—the aperture, or f-stop. Selecting a higher f-stop number will increase the area of sharpness in the image.

To help ensure that the whole of the macro image is sharp pick the biggest f-stop number possible to make your exposure.

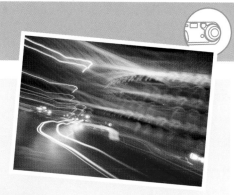

182 Check exposure

All digital cameras contain a metering system designed to measure the amount of light entering the camera. The meter is generally linked to an autoexposure mechanism that alters the aperture and shutter to suit the light that is available. In most scenarios, the autoexposure and meter systems work well, but there are times when the camera can be fooled. This can be the case when the scene is composed of mainly dark or mainly light subjects. The macro shooter needs to be aware of this problem and be able to alter the camera exposure to compensate when necessary. One of the easiest ways to modify exposure settings is using the Exposure Compensation control.

Macro subjects that are predominantly dark or light can fool the camera's meter and exposure systems. Be sure you know how to override the settings using the exposure compensation feature to account for these inaccuracies.

183 Set White Balance

White balance is important for macro work. For most situations, the Auto White Balance setting should provide good results, but on those occasions when the camera is fooled or when more accurate results are needed, try a customized setting based on measuring the color of the light reflected from a white test sheet.

Make sure that the White Balance (WB) setting suits your light source.

184 Adjust exposure for specific subjects

Use the following table of typical subjects and their associated compensation as a starting point for your exposure changes.

Subject	Change to exposure
Black type on white paper	More (+)
Snow scene	Same (no change)
Beach scene	Less (-)
Predominantly light-toned subjects	More (+)
Grass and foliage	Same (no change)
Predominantly midtone subjects	Less (-)
City scene at night	More (+)
Chalk on a blackboard	Same (no change)
Predominantly dark-toned subjects	Less (-)

185 Add a measure

When documenting small objects or details of a larger scene, including a ruler will provide a sense of scale to the image.

A ruler placed in the shot can give an accurate sense of scale to your pictures.

186 Reduce camera movement

It is important to keep the camera perfectly still during a macro exposure, as the slightest movement will cause the blur. A sturdy tripod coupled with a cable release is best, but failing that, the camera can be rested on a solid surface and the shutter activated with the self-timer.

Use a tripod and a cable release wherever possible to ensure images free of camera movement. When shooting handheld, turn on the Best Shot Selector feature to ensure the sharpest picture.

187 Plan ahead

If the camera is used handheld rather than on a tripod, select the Best Shot Selector (BSS) option from the shooting menu to obtain the sharpest image. This allows you to capture a series of images (up to nine) in a row. The software analyzes them and selects the image that has the best overall sharpness.

Techniques

In-camera sharpening

There are two schools of thought for deciding when and where to apply sharpening to your images. Some shooters apply it in-camera, using one of the camera settings (High, Normal, Low), or the Auto option. Others prefer to leave their images untouched for editing later. So why go for the former?

188 Why use in-camera sharpening?

To help create crisper images, camera manufacturers include in-camera sharpening as one of their Auto enhancement tools. Designed to improve the appearance of sharpness across the picture, these features enhance the edge of objects by increasing the difference in tones between adjacent pixels. In essence, the sharpening function boosts the contrast of the image at a pixel level. This creates an impression of greater clarity.

189 What settings should you use?

Most basic digital cameras provide the option of turning the sharpening feature off. Doing this does means that you take back control over where and how sharpening is applied to your image, but it also adds another, sometimes unwanted, step to the enhancement process. For situations where you have plenty of time to experiment, and where absolute quality is required, sharpening in your image-editing software certainly produces great results, but for most day-to-day imaging, applying a little sharpening in-camera is the best option for busy people.

190 Auto sharpening settings

This option allows the camera to search for the optimum settings for each individual image. The picture is analyzed and sharpening is applied to the edges of contrasting objects. The way that sharpening is applied will change as the subject matter changes. If you don't want to sharpen on the desktop, this is a good default setting.

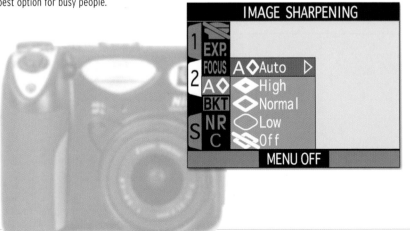

191 No in-camera sharpening

This option is for dedicated image editors only. Pictures captured with this setting will appear soft if you do not apply some desktop sharpening. Making this your default commits you to sharpening every image manually.

192 Low or minimum sharpening settings

This option is for shooters who worry about what their camera is doing to their images. This setting applies the least sharpening; it's a good choice if you generally apply sharpening via an image-editing package.

193 High or maximum sharpening settings

This option drastically increases the overall sharpness of all images. In some cases the change is so great that the sharpening is very obvious and distracting. Use this setting carefully, reviewing your results as you shoot.

Off

Low

High

194 Normal or standard sharpening settings

This option applies the same level of sharpening to all images. Designed as the most suitable setting for most subjects most of the time, there will be occasions when this selection applies too much sharpening as well as situations when not enough sharpening occurs. Generally, Auto provides a better all-round option.

195 Sharpening in your software

If you do go for sharpening in your image-editing software, then you'll find a range of options under the Sharpen submenu in the Filter dropdown menu, including Sharpen Edges and Unsharp Mask. However, remember that you can't pull a critically unsharp, blurry image into focus, only increase the contrast between edge pixels.

196 Don't overuse sharpening tools

If you opt to sharpen images in Photoshop or another image-editing application, then be wary of overusing the effect. If you apply one of the Sharpen filters more than a couple of times, the image will begin to develop artifacts and the edges will begin to appear unnatural and "processed" looking.

Continuous shooting

Your digital camera almost certainly offers you a range of continuous shooting modes. These will enable you to keep shooting the action and record it as a sequence of images, which can create a dynamic and exciting record of an event, or tell a story about your subjects...

197 What is Continuous shooting mode?

All but the most basic digital cameras will contain a variety of options for shooting a series of pictures. Usually hidden away under a menu titled "Continuous," these features switch your camera from taking a single shot per button push to recording multiple images, one after each other.

198 Why use Continuous shooting?

Being able to capture multiple frames has long been a favorite option for action shooters, and the inclusion of such features in the humble digital camera means that we can truly get into the action. Though there is a true sense of satisfaction and achievement in being able to capture the peak of an action sequence with a single button press, the success rate for all but the best shooters is pretty low. Capturing a stream of images that documents the whole action sequence improves your chances of getting the single image that defines an entire event.

199 Low-speed continuous shooting

This mode records images continuously while the button is held down. Even some midrange cameras are only capable of about 1.5 frames per second (FPS) in this mode. This rate is sustainable until the camera memory buffer fills, then the FPS rate will slow while the camera saves the pictures to memory. This speed may be possible with JPEG files, but perhaps not the larger TIFF and RAW formats.

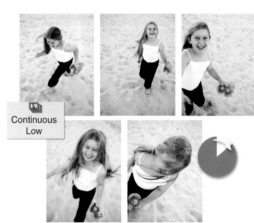

Continuous Low

200 Continuous high-speed mode

This is the fastest mode for most models, with speeds varying between three and eight frames per second on some cameras. Again, the rate may slow when the camera's buffer is full and the option may not be available when saving in RAW or TIFF formats. However, technology improves daily, so read up on the latest models.

201 Multi- or ultrahigh-speed shooting

Capturing at rates of up to 30 frames per second, this is the fastest of all the continuous shooting modes. The upper limit of the number of images that can be shot in one burst is generally governed by the size of the camera's memory buffer. On many cameras, high speed is possible because the maximum picture size is reduced sometimes to as low as 320 x 240 pixels and the file format may be strictly JPEG.

202 Movie mode

Many stills cameras have a Movie mode, which can record perhaps 15 to 25 frames per second. There is usually an upper limit on the length of time recorded of around 60 seconds. However, some models allow continuous recording until the camera's memory card is full. Image dimensions are restricted with most models, with an upper limit of 320 x 240 pixels. Most cameras save movie files in a non-still image file such as Apple's QuickTime format. Single frames can be extracted from the footage using features such as the frame from video feature in Photoshop Elements.

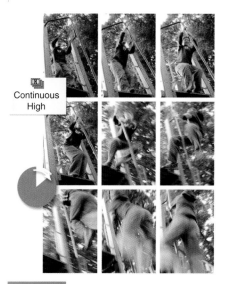

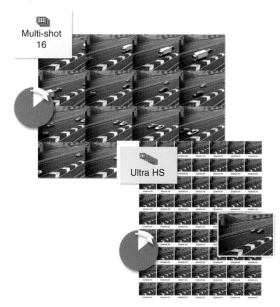

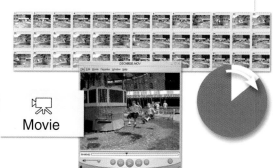

203 Get creative with your subjects

Continuous shooting modes are great for sporting events or action scenarios, but you may not be in these environments everyday. That's no reason not to get creative, though! You can have great fun with these modes–get your kids or friends to run towards the camera; capture them playing or playing in the garden. Seize–or rather shoot–the day!

204 Tips for comparing Continuous modes

- Check the frame rate (in frames per second).
- Check the sustain rate. Look for how many frames can be shot at the fastest rate before slowing.
- Find out which file formats work with the fastest rates.

205 More tips for comparing modes

- Check the frame rate (in frames per second).
- Check the sustain rate. Look for how many frames can be shot at the fastest rate before slowing.
- Find out which file formats work with the fastest rates.

Digital ISO

In the days of film, the "ISO" rating referred to a film's sensitivity to light—in other words, the speed at which it captured a scene. Fast films could grab images quickly and also be used in low light conditions, while slower films needed more light but produced less grainy images. Digital cameras free you from these restrictions and let you change the ISO setting for each image.

206 What is digital ISO?

In the digital era, you're no longer locked into shooting at the speed of the film in your camera. The ISO idea still remains, though strictly it Is "ISO equivalency," (ISO-E) as the original ISO (International Standards Organization) scale was designed for rating film. Most cameras allow you to change the ISO-E of the sensor, with a growing number offering settings ranging from 100 (slow) to 800 (faster). Each frame can be exposed at a different ISO value, so you are not limited to a single setting (or wasting a roll of film).

207 Adjusting sensitivity

Entry-level digital cameras usually have a chip sensitivity that is fixed by the manufacturer, but as you start to pay a little more, the level of control over the camera's ISO setting begins to increase. Most middle-of-the-range and "prosumer" (pro/consumer) cameras contain a variety of sensitivities. Changing the ISO is usually a matter of holding down the ISO button while turning a command dial. The changed setting is reflected in the LCD screen at the back of the camera and, in some cases, in the viewfinder as well.

208 The Auto ISO setting

Some cameras also contain an Auto ISO setting that can be selected instead of specific sensitivity values. This feature keeps the camera at the best quality option, usually 100, when the photographer is shooting under normal conditions, but will change the setting to a higher value automatically if the light starts to fade. It's a good idea to use this option as your camera's default setting. It works well in most situations and you can always change to manual when specific action or low-light scenarios arise.

Image shot at 100 ISO

Image shot at 200 ISO

Image shot at 800 ISO

209 Choosing ISO settings manually

Alternatively, you can select the sensitivity of the chip manually by choosing the ISO value to suit the lighting scenario. Use low values for scenes with plenty of light and higher settings for low-light situations.

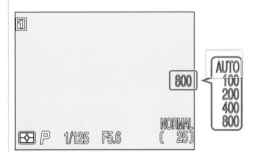

210 Low ISO equals crisper pictures

If you decide to select your ISO manually, or let the camera automatically adjust the chip's sensitivity for you, always keep in mind that choosing the lowest setting possible will give you the sharpest and best-quality images overall—so use it when you can!

211 Watch out for digital noise

Although you can change the ISO-E setting for each and every image, you are not completely free from the issues associated with ISO ratings from the days of film. Just as fast films tend to produce grainy images, so higher digital ISO settings produce noisier images.

212 No sharpening when using high ISO values

When using higher ISO settings, turn off the camera's Sharpening feature, as this tends to exaggerate any noise present in the image. Apply sharpening afterward in your image-editing program.

213 Match sensitivity to image quality

Sensitivity in digital terms is based on how quickly your camera's sensor reacts to light. The more sensitive a sensor is, the less light is needed to capture a well-exposed image. This means that higher shutter speeds and smaller aperture numbers can be used with fast sensors (higher ISO ratings). Sports shooters in particular need cameras with sensitive chips to freeze the action, and you need a sensitive chip for photographing in low-light situations as well. But as faster/higher ISO settings produce greater noise, you will need to weigh up the merits of higher sensitivity with the disadvantages of lower image quality when choosing what ISO equivalent value to use for a specific shooting task.

Benefits and disadvantages of different ISO settings

ISO equivalent setting	100	200	800
Benefits	- Low noise (fine grain) - Good color saturation - Good tonal gradation	- Good noise/sensitivity balance - Good sharpness, color, tone - Can be used with a good range of apertures and shutter speeds	- Very sensitive - Can be used with fast shutter speeds, large aperture numbers or long lenses - Good depth of field
Disadvantages	- Not very sensitive - Needs to be used with fast lens or tripod	- Not the absolute best quality capable - May not be fast enough for some scenarios	- Obvious noise throughout the picture - Poor picture quality
Best Uses	- Studio - Still life with tripod - Outdoors on bright day	- General handheld shooting	- Sports - Low light situations with no flash - Indoors

Exposure basics

Although great compositions and good focusing are essential for creating professional-looking photographs, good exposure is the foundation that underpins all of these factors. Although you can fix many problems later in your editing software, it is far better to learn how to capture well-exposed images in-camera than to waste time correcting your mistakes! Here are some tips to help you understand the basics of good exposure.

214 Learn how exposure works

The mechanics of creating a photograph are based on controlling the amount of light entering the camera and, in the case of digital photography, falling on the sensor. This process is called exposing the sensor. All cameras have mechanisms designed to help ensure that just the right amount of light enters the camera. Too much light, and the image will appear washed out (overexposed). Too little, and the picture will be muddy (underexposed).

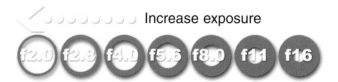

Increase exposure

f2.0 f2.8 f4.0 f5.6 f8.0 f11 f16

216 Learn how the aperture works

The aperture is a variable opening in the camera between the body and the lens. The smaller the hole, the less light is able to enter the camera via the lens. Conversely, if the hole is larger, more light can enter. The variable size of the opening is described in terms of f-numbers or "stops." Confusingly, the smaller the f-number, the larger the hole. It may be helpful to think of the aperture as being similar to your eye's iris. In bright light, the iris is small, restricting the light entering the eye. In dark situations, the iris grows larger to let in more light. So, increase the size of the aperture to lighten the photograph, decrease it to darken.

217 Learn how the shutter works

The shutter works like a roller blind in an office window—but at much higher speed! Opening it lets light into the camera, and closing it prevents light from entering. The length of time that the camera's shutter is open, called the shutter speed, determines the amount of light that enters the camera. Fast shutter speeds are used when photographing bright scenes to restrict the light coming into the camera, whereas slow shutter speeds (longer exposures) are used for nighttime or indoor photography. Faster shutter speeds are represented by a series of numbers that are fractions of a second. Slower speeds are displayed in whole seconds.

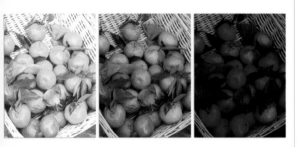

215 Controlling exposure

Two different camera parts are used to control the amount of light entering the camera: the aperture and the shutter. Learn how to use these two essential photographic tools.

1/8 1/15 1/30 1/60 1/125 1/250

Decrease exposure

218 Which shutter and aperture settings?

All cameras have a built-in metering system designed to measure the amount of light entering the camera. The camera uses this measurement as a basis for setting the correct shutter and aperture. Simple cameras use an autoexposure system that performs this function without the photographer being aware it is happening. More sophisticated models include manual override options. These allow you to take more control over the exposure process, selecting shutter speed and aperture.

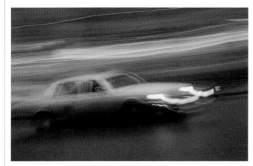

A slow shutter speed creates a feeling of movement in your images.

219 Sometimes the camera gets it wrong

For perhaps 85 percent of the time, there may be no need to disagree with the camera's meter or the settings that it uses, but there are occasions when the camera can be fooled. It is on these occasions when you need to anticipate the problem and take control. To ensure that you always obtain the best exposure, use the following guidelines.

BETTER EXPOSURE GUIDELINES

220 Use the camera as a guide

The metering system in your camera is very sophisticated and, for the most part, your camera will choose the right exposure settings. All but the most basic models allow you to see shutter and aperture settings in the viewfinder or on the LCD screen. Take a mental note of these and learn to recognize how your camera reacts to different light.

221 Fill the frame with your subject

Most meters use a subject in the center of the frame as a guide for the exposure of the whole image. One way to ensure that your image is well exposed is to make sure that the most important parts of the picture feature in the center of the frame, by which the camera calculates exposure. That said, be wary of monotonous compositions.

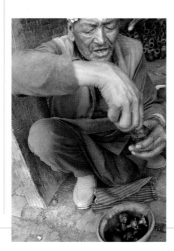

222 Use exposure and focus lock

You may wish to try designing the frame with your subject a little off-center. Doing this may help the look of your images, but your exposures might suffer. To solve this, it is helpful to know that most cameras have the ability to lock exposure (and focus) by pushing the shutter button halfway. For the situation where you want to create an off-center shot, point your camera at the subject and press the button halfway and then, without removing your finger, recompose the picture before firing the shutter fully.

223 Create your own reference guide

Assuming you have a manual override on your camera that allows you to set shutter speed and aperture, then here's a simple but useful idea for creating your own reference system. Take a series of photographs of a friend in the same location, each time holding a card that has the shutter speed and aperture of the image written on it (along with other details, such as the ISO setting). Then repeat the same exercise in different lighting conditions and at different focal lengths. Create an album on your desktop that contains all of these reference images and you'll soon learn what effect each combination of settings has simply by referring to the image.

224 Watch out for darker subjects

The camera's meter works on averages. When you point your lens at a scene, the meter averages the various colors, tones, and brightnesses in the scene to a theoretical mid-gray. The shutter speed and aperture recommended by the camera is based on analyzing how to reproduce this mid-gray in the available lighting conditions. In some circumstances this just doesn't work—for example, a shot that contains mostly dark subjects. Here, the camera will suggest settings that will result in the picture being overexposed. To compensate, simply increase your shutter speed setting by one or two stops, or close down your aperture by a couple of stops. Preview your results and reshoot if necessary.

225 Keep an eye on light-colored scenes

You should be wary of light-colored scenes for the same reason. Some prime examples are the types of images of the beach or snow. Most pictures in these environments contain large light-colored areas. Leave the camera to its own devices and you will end up with muddy, underexposed pictures. The solution is to add more exposure than the camera recommends. You can do this manually as detailed before, or try using your camera's Exposure Compensation feature. Usually labeled with a small plus and minus sign, this allows you to add or subtract exposure by pressing and turning the command dial. The change in exposure is expressed in fractions of f-stops. For beach and snow scenes, add up to two stops (try 1 or 1.5) and preview.

226 Be careful of backlighting

A portrait taken in front of an open window with a beautiful vista in the distance sounds like a recipe for a stunning photograph, but often the results are not what we expect. The person appears too dark and in some cases is even a silhouette. Assuming this wasn't your intention, then your meter has been fooled. The light streaming in the window and surrounding the sitter has caused the meter to recommend using a shutter speed and aperture that cause the image to be underexposed. To rectify this, increase the amount of light entering the camera either manually, or with your camera's exposure compensation feature. Shoot the portrait again and preview the results onscreen.

227 Histograms to the rescue!

Being able to preview your work immediately means that many of the exposure mistakes made during the days when film was king can be avoided. Any under- or overexposure problems can be compensated for on the spot and the image reshot. But you need not stop there. Many cameras also contain a built-in graphing function that can display the spread of tones in your image. This graph, usually called a histogram, can be used to diagnose exposure problems quickly and easily. A bump of pixels to the right-hand end of the graph means an underexposed picture, while a bump to the left end indicates overexposure.

Exposure compensation, bracketing, and fill flash

Good exposure is one of the cornerstones of great imaging, and there are numerous techniques you can master to ensure that you capture as much information as possible in your images and get the best possible results from your photography.

228 What characterizes poor exposure?

As we've discussed, images that result from the sensor receiving too much light are overexposed. The indications are that they typically have little or no details in the highlight portions of the image and the midtones are too bright. Underexposed images characteristically lose details in the shadow regions and their midtones are dark.

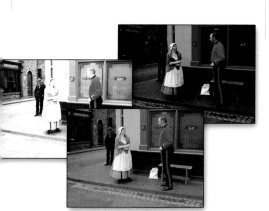

229 What is perfect exposure?

The perfect exposure will produce a picture that contains:
• A good spread of tones from light to dark
• Details in the shadow areas
• Details in the highlight areas

230 Using exposure compensation

This control effectively changes the shutter speed or aperture selected in steps of one-third of an f-stop (sometimes also called EV-exposure value). The value increases or decreases the exposure set by the camera in situations when the camera incorrectly reads the scene. Most cameras allow changes of up to plus or minus 3 stops. In tricky lighting scenarios, shoot a test image, preview, adjust, and reshoot.

231 When to use compensation

Don't be overzealous in your quest to produce the perfect exposure, however. Sometimes you can create stunning images by deliberately playing with the exposure—such as so-called "high-key" portraits, where skin tones are fairly bleached out but dark tones might still be rich and detailed. One way to achieve this is to use a very fast ISO setting and add a little exposure compensation. Experiment and see.

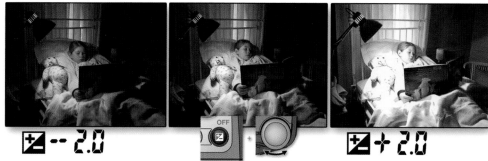

232 Using fill flash

A popup flash system provides another way of modifying the spread of tones in your image. In high-contrast circumstances, a little fill flash can help lighten impenetrable shadow areas that would otherwise show no detail.

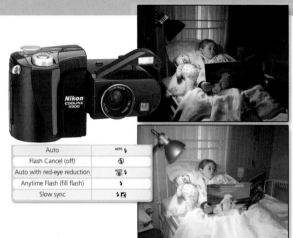

Auto	AUTO ⚡
Flash Cancel (off)	🚫
Auto with red-eye reduction	AUTO 👁 ⚡
Anytime Flash (fill flash)	⚡
Slow sync	⚡ 🌙

233 Autoexposure Bracketing

For those of you who hate the idea of having to readjust the camera each time you want to make a series of exposure compensations, the Autoexposure Bracketing function might be just what you need. This shoots a sequence of frames with different exposure settings. You can choose between a series of three or five shots and variations in exposure of up to + 2 or - 2 stops. This produces a range of photos from dark to light from which you can select the best result—useful when the camera might have difficulty determining exposure.

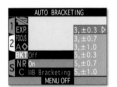

Option	No. of shots	Exposure increment	Bracketing order
3, ±0.3	3	±¹⁄₃ EV	+0.3, 0, –0.3
3, ±0.7	3	±²⁄₃ EV	+0.7, 0, –0.7
3, ±1.0	3	±1 EV	+1.0, 0, –1.0
5, ±0.3	5	±¹⁄₃ EV	+0.7, +0.3, 0, –0.3, –0.7
5, ±0.7	5	±²⁄₃ EV	+1.3, +0.7, 0, –0.7, –1.3
5, ±1.0	5	±1 EV	+2.0, +1.0, 0, –1.0, –2.0

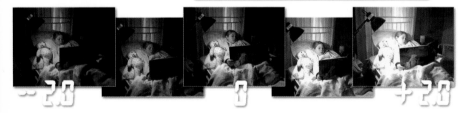

234 Balancing flash and daylight

Gone are the days when using flash with existing light meant working out complicated ratios and measuring the subject-to-camera distance. Now most cameras contain sophisticated exposure systems that can balance both the ambient light (the existing light already in the scene) and the flash light so that the picture is not overexposed.

235 Correcting fill-flash problems

The fill-flash option is another auto function that works well for most scenarios, but there are some instances when you may want a little more control of the flash output. For these occasions, the manufacturers have merged the fill flash and exposure compensation technologies to produce a feature that allows you to adjust the output of the flash independent of the main camera exposure.

236 Flash exposure compensation

The Flash Exposure Compensation feature provides one-third-of-a-stop adjustments for the flash output. Increasing the fill flash's power will mean that it becomes the main light source in the image; reducing the flash power will have the reverse effect so that the existing light dominates and the flash subtly fills the shadows. Use this to adjust the strength of flash in your picture.

⚡ + 2.0

⚡ 0.0

⚡ – 2.0

In-camera contrast control

Traditional film shooters have little control over the contrast in their images. Thankfully, this is not the case for most digital photographers. Almost all intermediate to high-end cameras contain a series of settings that control how the range of brightness in a scene is recorded to memory. With some camera manufacturers, contrast control features are becoming available even on modestly priced entry-level models.

237 Contrast setting for sunny-day shots

The contrast control is one of the most useful features for the digital camera owner. When you are faced with shooting a beach or snow scene on a sunny day, the range of brightness between the lightest and darkest areas can be extremely wide. Set to Normal, your camera's sensor can lose detail in both the highlight and shadow areas of the scene; delicate details will either be converted to white or black. Changing the setting to "less contrast" or "low contrast" will increase your camera's ability to capture the extremes of the scene and preserve light and dark details.

238 Adjust for more overcast days

In the opposite scenario, sometimes your subject will not contain enough difference between shadows and highlights. This situation results in a low-contrast or flat image. Typically, pictures made on an overcast winter's day will fall into this category. Altering the camera's setting to "more contrast" or "high contrast" will spread the tonal values of the scene over the whole range of the sensor so the resultant picture will contain acceptable contrast.

IMAGE ADJUSTMENT

1 A AO Auto ▶
 O Normal
2 S O+ More Contrast
BSS O− Less Contrast
AO ☼+ Lighten Image
S O ☼− Darken Image

MENU OFF

239 Diagnose contrast problems

How do you know that my scene either has too much or too little contrast? If you are in a situation where you feel that the image may be enhanced by altering the contrast, shoot a couple of test pictures and assess the results. Zoom in and check in particular the shadow and highlight areas. Any loss of critical detail here will warrant a contrast change and a reshoot—if you can, preview the images on a laptop to avoid being misled by the sometimes unreliable LCD screen.

240 Check the tonal distribution

Remember to use the histogram feature to take the guesswork out of determining whether your image is too flat or too contrasty. Use it to ensure an even spread of tone.

241 Exposure and contrast is critical

Selecting the right contrast setting is as critical as exposure if the greatest amount of detail is to be recorded by the sensor. With any in-camera setting, this is critical as image-editing software can't put back detail that wasn't recorded—at least in terms of capturing reality.

242 Bypass camera contrast

The advantages of shooting with correct contrast detailed here are only available when capturing in JPEG format. When using RAW, the full range of brightness that can be captured by your camera is stored in the file and the contrast changes (More Contrast, Less Contrast) are applied via the RAW editor on the desktop.

243 Choose your contrast options

• Auto
With this option, the contrast setting set by the camera according to the lighting conditions in the scene. Subjects with a large brightness range will be recorded with a low-contrast setting, whereas flatly lit scenes will be improved with a high-contrast setting. This is a good default.

• Normal
In this mode, the contrast setting is fixed. This setting is useful for standard "normal" lighting conditions, but should be used with care if the brightness in the scene is fluctuating. You may prefer to keep the camera at this setting and apply contrast correction on the desktop.

• More Contrast
This is used for low-contrast shooting conditions to enhance tonal values. This setting is designed for images shot under overcast skies, landscapes, and generally low-contrast scenes.

• Less Contrast
This option reduces the contrast of brightly lit scenes. It should be used in situations such as sunlit beach and snow shots, or where strong light creates dark shadows.

Stabilizing the camera

"Sure and steady" was a catchphrase that my photography teacher often used when teaching us how to hold our cameras. It was his way of ensuring that the camera wasn't moving when we pressed the shutter button. Your lenses can be as sharp as you like, but if you can't hold your camera steady then the image will be blurred, he'd say. His advice is no less true now in the age of digital as it was then when film was king. So, what are the options when you want to ensure blur-free pictures?

244 Correct camera holding

Slight camera movement, particularly when shooting at the long end of your zoom setting or in Macro mode, will cause the picture to be blurred. The longer the focal length of the lens, or the more zoomed-in you are, the more likely that camera shake will be visible. Use two hands to hold your camera, brace your body, or using a trusty tripod are all tried-and-tested methods for reducing camera shake.

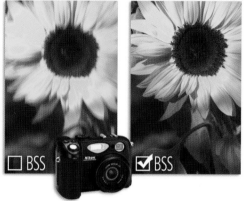

245 Shutter speed to the rescue

Another solution is to increase the shutter speed. The rule of thumb is the minimum speed used to ensure no camera shake is "1/" over the length of the lens. This means that if you are shooting with a 200mm (35mm equivalent) lens then you use a shutter speed no longer than 1/200 second.

246 A digital solution

There are times when a tripod may not be an option, and you can't select a faster shutter speed due to low-light conditions. With this mind, some manufacturers are adding shooting aids to their cameras that increase your chances of sharp pictures. The Nikon version of the technology is called the Best Shot Selector (BSS). When activated, it allows the photographer to shoot a range of images of one subject in a row. All the pictures are stored in the camera's memory and analyzed for detail. The software then compares each of the frames and determines which single image contains the best overall sharpness. This is saved to the camera's memory card and the rest are discarded.

247 Using BSS (Nikon)

The exposure, focus, and white balance options are determined for the first frame and fixed for the rest of the series. The camera continues to capture more pictures while the shutter button is pressed. There is a timelag between the final exposure and the selection of the "best shot," which restricts the photographer's ability to keep taking photographs, until the analysis and selection phases are complete. But in situations where camera shake might occur, this is a small price to pay!

248 Slowest shutter speeds to avoid shake

The lens-to-shutter-speed settings to use to avoid visible camera shake are: lens (mm) / slowest possible shutter speed (sec) 201/20; 501/50; 001/100; 2001/200; and 3001/300.

In-camera color

The saturation, or vividness, of color within your images can make or break them. Sometimes color is the cornerstone of a picture, providing both the focal point and design for the whole image. In these circumstances, desaturated or pastel hues will weaken the impact of the picture. By contrast, strong color elements can distract from important subject matter, causing the viewer to concentrate on the color rather than elsewhere in the image.

249 Saturation control

Take more control of the color content of your images by selecting how dominant or vivid the hues will be in your pictures. For shots that rely on color, the vividness can be increased; for those that work more effectively with subdued hues, the color strength can be reduced via the camera's Saturation control.

These are your options:

• Maximum: produces vivid color and can be used to boost the overall color in a dull picture.

• Normal: not boosted or reduced—good for most general shooting circumstances.

• Moderate: creates images with a slight reduction in color.

• Minimum: can be used to create low-saturation color photographs, or to reduce the dominance of color.

• Black and white: no color, leaving an image formed solely of gray tones.

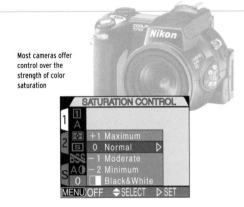

Most cameras offer control over the strength of color saturation

250 Which saturation setting to use

The effectiveness or suitability of each setting should be previewed. If necessary, several images with different color settings can be captured and the final choice made later. Though not as critical for retention of details as the contrast settings, it is important to capture as much color information as possible when shooting. This does not mean that you shoot all subjects with maximum saturation; it is just a reminder that if color is important you should consider changing the saturation settings to suit your objectives.

Adjusting the saturation in your image will change the strength of its colors. Reducing the saturation to zero will produce a black and white image; increasing the color strength to maximum will create a vivid picture.

251 Balance your whites

Adjusting the strength of your colors can be very effective, but only if the hues are recorded cleanly in the first place. Selecting an incorrect White Balance setting will cause your picture to take on a disturbing color cast that not only tints the whole photograph but minimizes the impact of the colors in the image. To ensure that your pictures are cast-free, match the White Balance settings on your camera with the lights that you are using to illuminate your subject. Use the "Incandescent" setting for standard household bulbs, the "Cloudy" or "Shade" option for images taken in the shadow of a building and choose the "Daylight" selection for pictures lit by the sun. In mixed lighting situations where different parts of the scene are lit by different light sources, selecting the Auto White Balance option generally gives you good results.

250 The best White Balance control

For the ultimate control, use the White Balance fine-tuning controls or preset option to be sure that your pictures are recorded cast-free.

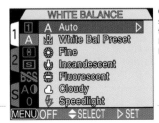

Good color control starts with selecting the appropriate White Balance settings for the lighting in your picture.

Using focus lock

Unlike the clunky, slow, and often temperamental mechanism that we called autofocus a few years ago, the feature as it now exists in most digital cameras is usually smooth, speedy, and very reliable. However, there are times when even these little marvels of modern-day engineering don't produce the results we want. How do you use autofocus when you want the main subject of the image to be to the left or right of the autofocus area?

253 Using the focus-lock feature

A solution to this problem can be found in a feature common to all autofocus cameras: the ability to lock the focus on a specific subject in the frame by pressing the shutter button down halfway. Simply reposition the subject (that you want sharp) in the center of the viewfinder and lock this focus point by pressing the shutter button down halfway. Next, while keeping the button pressed down, move the viewfinder so that the subject is now positioned off-center in the frame. You will notice that even though the center of the frame is now filled with a different subject, the focus remains where it was first locked. To take the picture, push the button down the rest of the way until the shutter is released.

254 Sharpness where you want it

The resultant image shows the sharp detail exactly as I had envisaged it. The shallow depth of field has blurred the background and the color and focus remains firmly off-center and in the foreground. For the first-time shooter, this way of taking a picture might seem a little strange, but after the first few tries this process will become second nature.

255 Using an off-center focus point

Cameras with a broad range of focus control also include features that allow the user to move the point of focus from the center to other areas in the frame. Another solution would be to scroll through the focus options and reposition the area of the frame the camera is using as a reference point so that it matches the position of the subject we want sharp.

It can be a difficult task to use an autofocus system when the point of interest is in the back of the frame and off-center. [Image courtesy of www.ablestock.com]

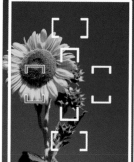

Using the shutter button to lock your focus, you can pick the focus point and then frame the picture to suit.

In some cameras, the portion of the viewfinder used as a focus reference point can be selected so that off-center subjects can be catered for by moving the focus area to suit.

White balance control

If you shoot a piece of white paper under florescent light, it will appear green; lit by an incandescent household bulb, it will look yellow. The color balance of artificial light is different from daylight, so you need to help the sensor by compensating using the camera's White Balance (WB) controls.

256 A digital solution

Film photographers were aware of the problems of shooting white objects under different light sources for years. They carried a range of color-conversion filters to help change the light source to suit the film. Digital camera producers, on the other hand, address the problem by including White Balance (WB) controls. These features adjust the captured image to suit the lighting conditions under which it is photographed. The most basic models usually provide Automatic White Balancing (AWB), but other cameras have a number of choices for correcting the problem.

General White Balance modes include:
- Auto
- Incandescent
- Cloudy
- Fine or Daylight
- Florescent
- Speedlight or Flash
- Preset or Custom

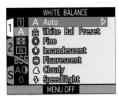

Many modern digital cameras contain sophisticated White Balance options under the WB menu.

Different colored light sources are responsible for the strange casts you sometimes see in your images.

257 Auto White Balance

The Auto White Balance (AWB) function assesses the color of the light in the general environment and attempts to neutralize the midtones of the image. As with most auto camera features, this setting works well for the majority of "normal" scenarios, but you may have some difficulty with subjects that are predominantly one color, or which are lit from behind. Also keep in mind that some subjects are meant to have a slight color shift from pure white and so the use of the Auto feature in this case would remove the subtle hue of the original. If in doubt, try the Auto setting first. Check the results on the preview screen of the camera and if a color cast remains, then move onto more specific options.

The Auto setting assesses the light falling on your subject and sets the white balance options automatically.

258 Light-source white balance settings

The Daylight (Fine), Tungsten or Incandescent (for household bulbs), Florescent, Cloudy, and Flash (Speedlight) options are designed for each of these light types. The manufacturers have examined the color from a variety of these sources, averaged the results, and produced a setting to suit. For those times when the source you are using differs from the norm, however, some cameras have a fine-tuning adjustment. With the light source set, turn the command dial to adjust the color settings. For Daylight, Incandescent, Cloudy, and Flash options, selecting positive values increases the amount of blue in the image. Alternatively, negative numbers increase the red content. If you have selected Florescent as your light source, fine-tuning feature allows you to select one of three different WB settings. FL1 is suitable for tubes marked "white," FL2 should be used with "daylight white," tubes and FL3 is for those labeled "daylight."

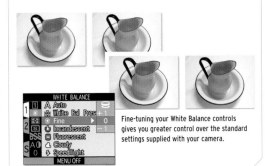

Fine-tuning your White Balance controls gives you greater control over the standard settings supplied with your camera.

 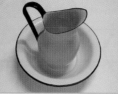

Option	Bulb Type
FL1	White (W)
FL2	Daylight White (Neutral [N])
FL3	Daylight (D)

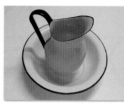

Three different florescent settings are provided with some cameras so you can fine-tune your WB settings for this light source.

260 Customizing your White Balance

In reality, most scenarios are illuminated by a variety of different-colored lights. For instance, a simple portrait taken in your room might have the subject partially lit by the incandescent lamp stand in the corner, the florescent tube on the dining room ceiling, and the daylight coming through the windows. Here you should use the Customize White Balance option. Based on video technology, this works by measuring the light's combined color as it falls onto a piece of white paper. The camera then compares this reading with a reference white in its memory and designs a setting for your scenario. It takes into account changes in color that result from:

- light reflecting off brightly painted walls
- bulbs getting older
- mixed light sources
- light streaming through colored glass
- shooting through colored filters.

The Auto White Balance Bracketing features available in some cameras captures several images with different settings, giving you the opportunity to select the best result back at the desktop.

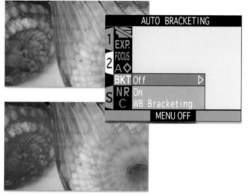

258 Applying fine-tuning automatically

If you are like me and find that manual fine-tuning hampers the flow of your photography–shoot, stop, switch to menu, fine-tune white balance, shoot again, stop, switch to menu, and so on–then check to see if your camera has an Auto White Balance Bracketing option. This feature automatically shoots a series of three images, starting with the standard white balance settings and then adding a little blue and finally a little red. White balance bracketing is particularly useful when shooting difficult subjects, such as the hand-blown colored glass shown in the example (right). As three separate images are saved, you can make decisions about the most appropriate color by previewing them on your monitor later rather than the small preview screen on the back of your camera in the field.

261 Calibrate your monitor!

If you are going to view the images later on your desktop monitor and check for color casts, then ensure that you regularly calibrate your monitor so that you know it is displaying colors accurately.

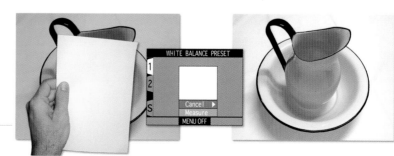

Shooting objects that appear white to the human eye under artificial light sources confuses cameras and creates whites that have a green or yellow "color cast." The WB function compensates for the color of the light source.

Shooting For panoramas

When producing great panoramas, the importance of the photographic step in the process cannot be underestimated. It is here that much of the final quality of your panoramic scene is determined. A few extra minutes taken in the setting up and shooting phases will save a lot of time later sitting in front of the computer screen fixing problems.

262 Set up your camera

Some cameras feature shooting modes that aid the capturing of the overlapping source images needed for creating panoramas later in Photomerge (Photoshop / Photoshop Elements). The Stitch or Panorama Assist mode ghosts the edge of the previously shot image on the monitor so that the user can line up the scene for the next photo. With most versions of the feature, the user selects the direction that the camera will be rotated during the shooting sequence. The exposure, white balance, focus, and aperture are set in the first exposure of the sequence.

263 Set up your shot

Serious panoramic shooters always work with a tripod and a panoramic or "VR" (virtual reality) head. This is designed to place the nodal point of the lens directly over the pivot point of the tripod. This makes it easier for your stitching software to blend the edges of your images accurately. Kaidan and Manfrotto manufacture VR heads.

264 Think exposure!

As the lighting conditions can change dramatically while capturing a sequence for a panorama, it is important to set exposure manually. Take readings from both the shadow and highlight areas of the scene before selecting an average exposure setting, or one that preserves important highlight or shadow detail.

265 Always overlap

As you are shooting, ensure that the edges of sequential images overlap by between 10 and 40 percent. The exact number of images needed to complete the full circle will depend on the angle of view of the lens as well as the amount of overlap. VR heads stop at regular points, creating a consistent degree of rotation as you shoot.

266 Go for manual focus

The autofocus mechanism should be switched to Manual so that no changes to the focal areas of the pictures appear in the final image. In this way the entire panorama will appear to be a single picture.

267 Shoot your home

Cities, landscapes, and vistas are obvious candidates for panoramas, but you can have fun shooting in your own home. Why not add a surreal edge by persuading a friend to be in each still?

268 Join a community

There is a large online community of VR photographers who publish virtual tours of buildings, places, and cities that are stitched together from still images. Google "VR photography" and see if you want to join a forum.

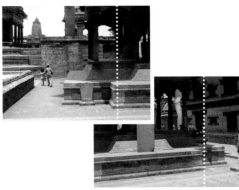

Flash photography

When the sun goes down or you move indoors, there is no need to stop shooting. Most modern digital cameras are capable of capturing great pictures under low-light conditions with the aid of their sophisticated flash systems.

269) Flash options

A built-in flash is familiar to most of us, but it can be a clumsy tool unless you know how to use it. Once activated, the flash synchronizes with your camera's shutter, firing a short beam of light to illuminate the subject or scene. The strength of built-in flash systems is often limited and they are best used for subjects close to the camera. For more power and flexibility, most camera manufacturers make external flashes that can be attached to the hot shoe of your camera, if it has one. These units link directly to your camera's controls and provide integrated control of your camera's exposure system and the flash's output.

270) Use flash like other lights

For the best results with flash, think of your system as a tiny studio light. On its own, it is very small compared to the size of most subjects and it creates light that is contrasty and direct. Add to this the fact that the flash hits most scenes head-on and you will find that a lot of flash photography is flat with tell-tale harsh shadows. Rid your images of these by changing the direction and quality of the light. If you can move your flash off-camera using either a cord or a wireless feature, then reposition it so that it sits to one side and slightly above your subject. To soften the light, you could bounce the flash off the ceiling or a white reflector, or pass it through a diffuser. Remember, it is the quality of the light that affects how your images look.

271) Removing shadows

Many of you will be thinking, "the only way to get good flash shots is to buy more kit." Well, this is best, but it is not the only way. If you have to rely on your built-in flash and you don't want harsh-edged shadows, then:
• move your subject away from the background by a couple of meters
• try to position background walls so that they are not directly in front of the camera
• use the slow shutterspeed option (with a tripod) so that the other lights in the room will help to balance the flash.

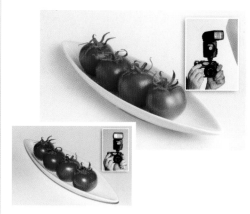

272) Learn about your flash modes!

• Anytime flash (Fill flash)
The flash fires every time a picture is taken. Use this option for filling in shadows when photographing in bright sunlight.
• Auto with red-eye reduction
This is designed to reduce the red-eye problem you often see in shots taken with compacts. In most models, a series of small flashes is fired before the main exposure.
• Auto
This option automatically fires the flash when it is dark or the light level is low. This setting is the best choice for most shooting circumstances.
• Slow-shutter flash
This option means that you can combine a long shutter speed with the flash operation. It is best used for night-time portraits where the flash lights up the person while the long shutter records the night or city lights.
• Flash cancel
This option turns the flash off completely.

Anytime flash

Auto with red-eye reduction

⚡ AUTO

Auto

Slow-shutter flash

Flash cancel

FLASH SETUPS

273 Built-in

The easiest way to get into some flash photography is to use the speedlight built into your camera. Most compact digital cameras and even some SLRs have them.

274 External (direct)

Add an external hot-shoe-connected flash to your camera and gain more power and control over your flash pictures.

275 Bounce (ceiling, bounce card, wall)

Get away from the "police mugshot" look by turning the flash head upward and bouncing your flashlight off the ceiling. This creates a much more diffused light source. If there is no ceiling handy, then turn the flash head to the side and use a light-colored wall. This provides a light that has similar characteristics to windowlight.

276 Diffuser attachment

If your flash heads don't rotate, you can soften the light using an attachment that spreads the light from the flash. Some models are supplied with diffusers designed for just this purpose. Alternatively, you can purchase a diffuser for almost any model from a supplier such as Lumiquest (www.lumiquest.com).

277 Off-camera (cable or wireless)

For those of you who want to use your flash as a studio light replacement, you can free your unit from its hot-shoe base using an extension cable. The cable maintains the flow of exposure and triggering information while allowing the photographer to position the flash head away from the camera. The most sophisticated models on the market can provide this functionality without a cable. The pop-up or built-in flash fires the main unit wirelessly, while the exposure calculations are handled by the camera. Many professionals carry a couple of these units, which they distribute around to provide a multiple-light setup.

New camera setups

Are you finding it difficult to wade through the manual and the menu tree of your digital camera? Then use this section as a guide for selecting the right features for specific shooting circumstances. Simply locate the requirements for the photo from the list and then adjust your camera settings to suit!

SETUPS FOR SPECIFIC SCENARIOS

Many SLR and compact digital cameras contain a range of specialist shooting modes designed to optimize the cameras' settings for specific shooting scenarios. Here we tell you when to use what modes.

277 Night portraits

When photographing at night with a subject in the foreground and city lights in the rear, choose the Night Scene or Night Portrait mode. This will set the camera so that it flashes the foreground subject and balances this with a long exposure for the background scene. Use a tripod or rest your camera on a steady surface. To duplicate the same results manually, switch on the flash, choose a long shutter speed, activate the camera's Noise Reduction mode, and turn off any sharpening.

278 Indoors

For family gatherings held inside and mainly lit with artificial light, select the Indoor Shooting mode. This mode adjusts the camera so that the color of the mixed light sources is neutralized and the existing light is used as much as possible in preference to flash. This said, indoor shooting modes often prevent camera shake by restricting the lowest shutter speed that can be selected and, if the lighting circumstance is still too low, automatically activate the flash. When you want to shoot in low light with intentionally longer shutter speeds and no flash, choose something like Fireworks mode. Alternatively, you can create the same camera setup by turning off the shooting sound, switching on any camera-shake warnings, and where possible, using a lens that contains vibration reduction features. Select a high ISO and set the White Balance feature to Tungsten (incandescent/lightbulb) or Florescent.

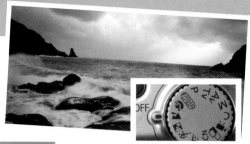

280 Freeze the action

For freezing the movement in sports or action photos, choose the Fast Shutter or Sports mode. With some cameras, this may also be called the Kids and Pets shooting mode. To recreate the settings manually, switch on the High-speed or Continuous Shooting mode, select a high ISO value, and set the camera's mode to Tv or S (shutter-speed priority). With these modes, the user selects the shutter speed and the camera adjusts the aperture to suit. To freeze action, select shutter speeds higher than 1/250sec.

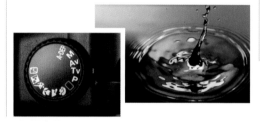

281 Blur the action

To blur the movement of a subject, use the manual settings above but this time select a slow shutter speed. The longer exposure time means that the subject moves during the time that the shutter is open, causing it to be recorded as a blur. Sometimes you may need to use a low ISO value.

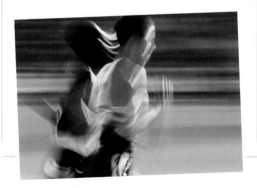

282 Lovely landscapes

The Landscape shooting mode ensures good sharpness throughout the picture and works well with scenes that contain detail right from the foreground through the middle section of the picture to the background. To duplicate the effect, switch to Aperture Priority mode and select a high aperture number (f/22 or 32) to ensure maximum sharpness throughout the photograph. The camera will automatically adjust the shutter speed to accommodate for the aperture selection. Use a tripod to avoid camera shake.

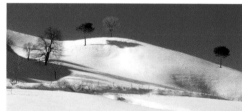

283 Cool snow scenes

When shooting scenes that contain large amounts of white, such as snow (or tropical sands), the results can end up being muddy (too dark) and in the case of snow shots, too blue. To help correct this, always select the Beach or Snow shooting modes on your camera. If you don't have these options, use the exposure compensation feature to increase the overall exposure and counteract the tendency for the camera's meter to be fooled by the bright white areas in the scene. When shooting on sunny days, reduce the contrast of the photos by selecting the "less contrast" option in the camera's shooting parameters.

284 Brilliant sunlight

Most cameras assume this to be the "normal" shooting scenario! Selecting P or Program mode generally suits this the best as the camera selects both shutter and aperture settings according to the subject's brightness. For those who prefer more manual control, with the extra light available you can use low ISO values (for clarity), high shutter speeds (to freeze movement), and big aperture numbers (for overall sharpness). In extreme conditions, try filling in shadows under the brims of hats with Fill flash.

285 Portraits

Portrait mode keeps the main subject sharp while blurring other details in the foreground and background of the photo. To reproduce these settings yourself, use small to middle aperture values (f/4.0-f/8.0) and medium or long lens settings (80-135mm-35 mm equivalent). In low light, always use a tripod to ensure that your pictures are shake-free. When your subject is placed against a mainly white or mainly dark background, use a center-weighted metering mode to ensure the subject's brightness values are being used to control overall exposure.

286 Stormy skyshots

For shooting on gloomy days, select picture modes such as Overcast or Cloudy. These options are designed to increase the contrast of the tones and the strength of the colors in the photos. To produce similar results manually, increase both the Saturation and Contrast settings in your camera's shooting parameters and, if light is low, change the ISO to a higher setting.

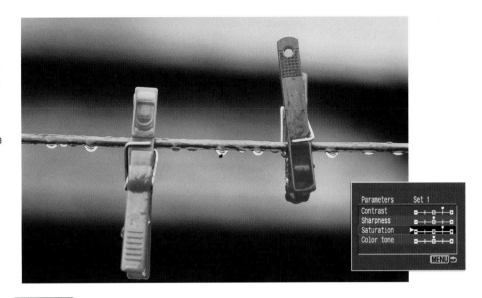

287 Mean Macro modes

Many cameras now contain a specialist Macro or Close-up shooting mode designed to let you get in really close to your subjects. When used with the camera on a tripod and some careful lighting, truly amazing close-ups are possible with even the most basic kit. To shoot macro without the Close-up mode, set focus to Manual and move the camera in and out to focus the scene. Employ the LCD monitor on the back of the camera to check focus and not the viewfinder, as this can lead to incorrect framing due to parallax error. Use a remote release, or self-timer.

288 Top-quality underwater shots

Affordable underwater housings are available for a variety of compact cameras. Some models also contain the option to select a special Underwater shooting mode that ensures optimal white balance with settings designed to reduce the blue-green tones that often appear in below-the-surface water shots. If your camera doesn't include this option, try the Auto White Balance feature first, and if the cast still remains, create a Customize or Preset White Balance option.

Creative lens usage

The lens is a critical part of any photographic system. Although there are many factors that help determine picture quality–such as having a good eye–the quality of your picture is certainly influenced in part by the chunk of glass in front of the camera. So here are some tips for getting the best out of whatever lens system you have.

289 Lens types: zooms

By far the most popular lenses today are zooms. A zoom is any lens that can change its focal length. More accurately they are variable-focal-length lenses. Zooms were originally produced in the telephoto range–usually around 80mm to 200mm focal length–hence many people confuse them with telephoto lenses. These days, the focal range covered by modern zooms is nothing short of amazing. From wide to telephoto in one compact (albeit sometimes weighty) package. No doubt this is the reason why most cameras are fitted with a zoom–which you may be stuck with! All the major companies produce zooms for a range of focal lengths, starting with wideangle options such as the Nikon 12-24mm f/4.0, through mid-range options like Sigma 24-70 f/2.8 to the telephoto variety such as the Canon 100-400mm f/4.5-5.6. Fixed lenses are now mainly used for applications like macro, low-light, and perspective correction.

290 Zoom lens score sheet

Advantages
• No need to change lenses for different types of shoot
• One lens covers the focal lengths of several fixed lenses
• Image quality and sharpness are generally good
• New designs are compact in size
• General models are well priced
• Professional models come with a fixed maximum aperture throughout the whole zoom range.

Disadvantages
• Generally slower than fixed lenses (most have a smaller maximum aperture, e.g. f/4.0 or f/5.6).
• Sometimes picture distortion in wideangle zooms is greater than for fixed lenses of similar focal length
• Not so good for low-light scenarios. Entry and mid-priced models have a variable maximum aperture across the zoom range (e.g. f/4.0-5.6)
• Some models display low-contrast results due, in part, to the many glass elements used in the construction.

LENS LENGTHS AND USES

291 Fisheye lenses 6mm to 18mm

The specialized fisheye lens is the ultimate in extreme wideangle. Whereas a normal wideangle lens is corrected for the aberration called curvilinear distortion, a fisheye lens has this as its most obvious characteristic. In practice, this means that subjects, especially straight lines, barrel-distort: they appear curved. Fisheye lenses have an angle of view of at least 180 degrees. The Nikkor 6mm (now discontinued) had an amazing 220 degrees–which meant that the lens could even look backward. Fisheye lenses with very short focal lengths give only a circular image.

• Uses: special effects, landscape, architecture, panoramas
• Pros: massive angle of view, curved distortion
• Cons: cost, curved distortion

293 Standard lenses 40mm to 55mm

A standard lens for a 35mm camera should have a focal length of 43.2mm. The more popular standard lens is the 50mm. These lenses are useful for a number of reasons. They will record a scene fairly similarly to how we see it, and they are popular as lenses for documentary-style photography. A fixed-focal-length standard lens is also generally both an inexpensive lens and one that is very capable of taking photos under poor lighting conditions.

Uses: general photography, portraits, documentary
Pros: inexpensive, good for low light
Cons: neither wide nor telephoto

292 Wideangle lenses 13mm to 35mm

If your camera can switch lenses, make sure you have a wideangle. The most common are 24mm and 28mm focal lengths. Wideangles are great lenses for many situations–landscapes, interiors, group photos, and so on. They are also very useful for letting your pictures tell a story including both your subject and the surroundings in one picture. Wideangle lenses inherently take pictures with greater depth of field.

• Uses: landscape, interiors, documentary, group portraiture, architecture, panoramas
• Pros: wide angle of view
• Cons: edge distortion with some models

294 Telephoto lenses 60mm to 200mm

Telephoto lenses have a telescopic effect: the longer the focal length, the greater the magnification and the smaller the angle of view. Lenses in the 70mm to 200mm range are termed medium telephoto lenses. They will allow you to take closer, often more interesting, photographs of subjects than standard lenses without having to move closer. Being reasonably portable, they make great travel lenses. They are also ideal for many other types of photography, portraiture in particular. Lenses with focal lengths of 200mm and more offer benefits that many photographers, notably of nature and sport, find almost essential. They allow photographers to take close-up pictures in situations where it is either impossible or undesirable to approach a subject. These photographs can have great impact, often allowing the photographer to dramatically isolate a subject for a photograph.

Uses: sports, portraiture, wildlife
Pros: gets in close, isolates the action
Cons: cost, shallow depth of field, size

295 If you don't own a digital SLR...

...don't think that you have been forgotten. Most of the manufacturers of compact digital cameras also produce auxiliary lenses that are designed to act in conjunction with your camera's existing lens, providing either wideangle or telephoto options. For most cameras, these lenses screw to the front of the camera using the filter thread. Some cameras will require a lens adaptor.

296 Maximum aperture

The first aperture on your lens is one of the lens's most important specifications. It is known as the lens's maximum aperture. This represents your lens's widest possible f-stop (smallest f-number/biggest aperture hole). This is because the maximum aperture of your lens controls how bright your camera's viewfinder will be–the wider the maximum aperture, the brighter the image. The maximum aperture might not always start on a full f-number and you will easily find lenses starting at f/1.8 or f/3.5 and then proceeding in the standard f-stop pattern after that (f/5.6, f/8, and so on). As zoom lenses can vary their focal length, their maximum aperture may also vary. Some models have a constant maximum aperture such as an 80-200mm f/2.8 lens. With this type of lens, the aperture also changes physical size as the lens zooms. The more common (and cheaper) zoom lenses have variable maximum apertures, i.e. a 28-85mm f/4-5.6. The aperture does not always alter its size as the lens changes focal length. Though not a problem when you are photographing generally well-lit subjects, the bigger maximum aperture numbers associated with economical zooms can be a real problem in low-light scenarios or when you are trying to use faster shutter speeds. As aperture is a key factor in the depth of sharpness in your image, the bigger maximum aperture numbers will also mean less ability to produce shallow depth of field effects.

297 Lens multiplication and angle of view

When lenses originally designed for the 35mm (135) film format are used with most digital cameras (the full-frame Canon 1Ds being the exception), the angle of view seen through the camera changes. Many people believe that the lens's focal length is increased and they use a multiplication factor published by the camera companies to compare the changes. As an example, Nikon cameras have a constant multiplication factor across the whole range of SLR digitals of 1.5. So, with a D100 coupled to the 12-24mm F4.0 lens, most people believe that it would become an 18-36mm lens. In fact, there is no change of focal length as you switch the lens from one format to the other. The actual change is that the picture angle of the lens is narrowed on the digital format because the sensor is smaller than a 35mm frame. Focal length and reproduction ratio remain constant for the comparable viewed portions of the image.

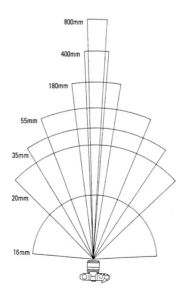

298 Single and Constant autofocus modes

These two modes determine the way in which the autofocus system works on your camera. In Single Servo mode (S), when the button is held halfway down, the lens focuses on the main subject. If the user wishes to change the point of focus, they will need to remove their finger and repress the button. If the subject moves while you are using this mode then you must refocus. The Constant or Continuous Servo focusing mode (C) again focuses on the subject when the shutter button is half pressed, but unlike Single mode, when the subject moves the camera will adjust the focusing in order to keep the subject sharp. This is sometimes called focus tracking. Some AF systems have taken this idea so far that they have pre-emptive focusing features that not only track the subject but analyze its movement across the frame and try and predict where it will move to. This helps keep the subject sharp.

299 Ultrafast, ultraquiet, motorized lenses

Lens manufacturers are always trying to gain more focusing speed from their lenses. One way they achieve this is by installing a small motor in the lens. This speeds up AF times by getting the lens to do the work rather than having the body drive the focusing mechanism through a mechanical connection. Nikon calls its technology Silent Wave Motors (SWM) whereas Canon has adopted the USM or Ultrasonic Motor label. A further refinement restricts the shutter from being released until the subject is sharply focused. This is useful for shooting subjects that are moving toward the photographer.

300 Image stabilization

Long lenses are hard to hold steady, which is why the major lens producers have released lenses containing Image Stabilization (IS-Canon) or Vibration Reduction (VR-Nikon) technologies. These lenses allow shooting at slower shutter speeds than traditional long lenses with little or none of the tell-tale camera shake that would normally be noticed. These lenses are great for shooting in low-light situations as they enable you to continue shooting with shutter speeds that would normally be too low to hold steady. Be warned, though –just because these lenses reduce camera shake, they won't help to freeze the action of a fast-moving subject.

301 Take care of lenses

Where possible, fit a UV filter to the front of each lens. As well as protection from dust or scratches, the filter will absorb impact if the lens is accidentally bumped, dropped, or knocked. If this happens, it is easier and cheaper to screw in a new filter than to replace a costly front lens element. To clean a lens or filter, blow any dust off the surface, then using a special lens cleaning tissue or cloth, moistened with lens cleaning fluid, wipe the surface gently in a spiral motion from the center to the outside, ensuring you don't leave any traces of fluid behind.

302 Portraits with blurred backgrounds

Making a portrait picture where the subject is sharp and the background is blurred is a classic lens technique used by all photographers who want their subjects to stand out from cluttered and often distracting backgrounds. You will need to select a longer than standard lens length such as 85-130mm and couple this with a relatively small f-stop number such as f/4.0 or f/5.6. This lens length and aperture combination will give you sharpness (depth of field) that extends from just in front of your subject to just behind it. Other elements in the picture such as those in the foreground and in the background will be blurred.

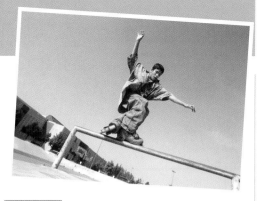

303 Shooting sports with zone focusing

When shooting sports, fast action really takes its toll on autofocus systems. Combining long lenses with fast movement often means poorly focused pictures, no matter how fast or accurate the auto focus system is. So instead of trying to follow the action with your camera lens focusing and then re-focusing continuously try the technique the pros use: zone focusing. There is a range of activities that allow the photographer to predict where the subject will be with reasonable accuracy. In swimming, for instance, the lanes and end points of the pool are well defined. To use this technique, the photographer would prefocus on one point with the lens in Manual mode and wait for the subject to pass into this zone before pressing the shutter. So, next time you are at a sporting event, set your zoom to a long focal length (150-300mm) and switch your focusing to Manual.

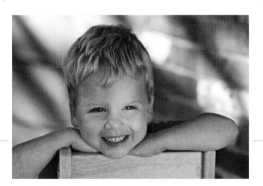

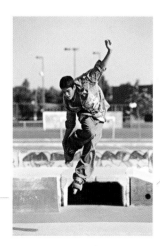

Editing

General tips on using Photoshop

If you use Photoshop or Photoshop Elements then you already have a packed instruction manual to plough through, but here are some simple and accessible hints and tips for a stress-free working life with your image-editing software...

304 Calibrate your screen

Calibrating your screen is the start of obtaining predictable results. Before starting to perform critical tonal or color corrections to your images, you need to use a feature like the Adobe Gamma screen calibration program to optimize your display settings. This utility profiles your screen so that colors and tones display accurately (and consistently with other monitors).

305 Undo unwanted editing changes

If you want to undo an edit, use the Ctrl (or Apple) Z keyboard shortcut to undo your last action, and use Ctrl + Alt + Z to undo multiple steps sequentially.

306 Add an even border around a picture

Instead of working out exactly how much the new dimensions of a picture will be with a border added, try ticking the Relative button in the Canvas Size dialog (Image > Canvas Size) and then input the size of the extra width and height you want to add to the picture.

307 Adapt the Healing brush

You can make the Healing brush behave more like the Clone (Rubber Stamp) tool by switching the Healing brush's blending mode to Replace. In this mode, the sampled area is not blended with the pixels below but pasted over them.

308 Preview filter changes at 100%

When applying filters, always make sure that your image (or preview thumbnail) is displaying at 100 percent or greater so that you can check the results more closely before hitting OK.

309 Change brush size

Increase the size of a brush by clicking the right-hand square brackets "]". Decrease the brush size using the left-hand square brackets "[".

310 Name your layers

To rename a layer from the default name supplied by Photoshop, click on the text of the layer in the Layer palette; this will enable you to enter a new title and keep track of all your elements.

311 Master selection techniques

Often it is the quality of the selections used in editing and enhancing techniques that determines how professional the results look. Practice the many selecting techniques available in Photoshop to improve your skills.

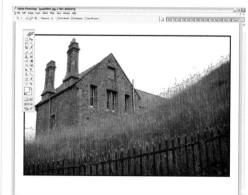

312 Learn keyboard shortcuts

Take note and memorize the keyboard shortcuts of your most-used menu selections or tools. Using them will speed up your editing work.

313 Use Auto features sparingly

Auto features are quick but lack the control of the manual versions. For best results, always use an editing or enhancement method that allows you to make manual adjustments.

314 Control filter effects

You can fade filters immediately after applying by selecting Edit > Fade. Alternatively, try applying the filter to a copy of the picture layer and then using the opacity slider to blend the layer with the original.

315 Move selections

Move a selection (the moving dotted line) using the arrow keys on the keyboard. Hitting a key will nudge the selection along by one pixel. Alternatively, with the Marquee tool still active, click and drag inside the selection.

316 Quick document info

Right-clicking on the title bar of your image displays a popup menu containing: Duplicate; Image Size; Canvas Size; File Info; and Page Setup.

317 Select any hard-to-see edges

When the edge of a dark object gets lost in the background, copy the image layer, adjusting its brightness until the edge is visible, and then use this layer to create the selection. Trash the copied layer and use the selection on the original.

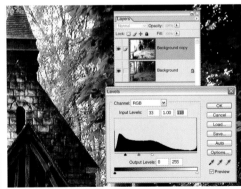

318 Roll up your palettes!

Keep your desktop clutter-free by rolling up palettes until you need them. Double-click the top bar of the palette to roll up and unroll.

319 Free up memory

Free up space to execute complex corrections on big images by purging Photoshop's memory (Edit > Purge). You can free up all the memory using Purge > All, or just those sections filled with Clipboard (Purge > Clipboard); History (Purge > History); or Undo (Purge > Undo) components.

320 Save original files uncompressed

Use the native file format in Photoshop (.psd) to save your original files. This will ensure that the best quality and features of your images are maintained.

321 Move multiple layers together

To move a number of objects that occupy different layers, select one of the image layers and then click the space next to the eye icon of each other layer. A chain icon appears to show that the layers are now linked. Once linked, the objects can be moved or adjusted using any of the transformation tools.

322 Convert background layer to image layer

To convert a background layer to an image layer, double-click on the layer's label and add a title. It can now be edited like any other layer.

323 Snap off

By default, Photoshop will usually snap the edge marquees and cropping selections to the edge of the document. To regain control over your selection near the document edges, hold down the Ctrl (or Apple) key after you click and drag. To turn off Snap, go to View > Snap.

324 Shift things into proportion

Keep object height and width in proportion by holding down the Shift key while moving one of the corner handles. Use the Shift key in conjunction with drawing and marquee tools to draw perfect squares or circles.

325 Quick fills

Fill a layer with the foreground color by clicking Alt + Backspace. To fill with the background color instead, use Ctrl + Backspace.

326 Move the view while in action

Change to the Hand tool (to move your image) by holding down the spacebar. Use the spacebar then click and drag to move a picture no matter what your current tool selection is. Releasing the spacebar returns Photoshop to the previous tool (except when using the Text tool).

327 Non-destructive changes

Use Photoshop's Adjustment layers to make changes to your images. Then, if need be, these adjustments can be further refined, or removed altogether, with no detrimental effects left on the original picture.

328 Try grainy film effects

Use the Add Noise filter (Filter > Noise > Add Noise) to add a quick film-grain look to your work. Select the Monochrome option to restrict the pixels added to your picture to tones of black, white, and gray.

329 Add a colored border

Use the Select > All command and then stroke the selection (Edit > Stroke) with settings of your choice of pixel width and color on the inside of the selection. Click the color swatch to change the color of the border.

330 Crop to a specific size and resolution

Click on the Crop tool and input width, height, and resolution in the Option bar. Click and drag the Crop tool to select the crop area. Hit Return to crop.

331 Control your sharpening

Use the Unsharp Mask filter to give you control over how much and where the sharpening is applied. With the preview set to at least 100 percent, adjust the Amount (strength) slider to a starting point of 150 percent, Radius to between 1 and 2 pixels, and Levels to 0 for general use and 5 for portraits (so that sharpening doesn't occur on skintones).

332 Adjust tones

Use the Levels feature in Photoshop as a way of adjusting the tones. This provides a graphical display of the spread of pixels, which allows more careful changes than the simple Brightness/Contrast slider control.

333 Improve contrast in flat scans

Select the Levels feature (Image > Adjustment > Levels). Move the Black and White output sliders toward the center of the graph until they meet the first group of pixels. Move the midpoint slider to the right to darken midtones and to the left to lighten them.

334 Create outlined text

With the Text layer selected, choose Layer > Layer Style > Stroke. Alter the size, position, and color of the outline (or stroke) in the Stroke dialog.

335 Hide all the palettes

Once you have selected a tool, you can hide all the palettes and dialogs by hitting the Tab key. Using Shift + Tab keeps the toolbar visible.

336 Dock unused palettes

Clear your workspace by dragging unused palettes that you want to access later to the dock. Each palette is then accessed by clicking on the appropriate tab at the top of the box.

337 Zoom in to ensure accuracy

If you have a small screen, it is still possible to work on fine detail within an image by zooming in to the precise area that you wish to work on. Zoom in is Ctrl + and out Ctrl -.

338 Change screen mode

Change from standard to full-screen mode with menu bar by clicking the F key. Change to the full-screen mode with no menu bar and a black background by clicking F again.

339 Learn quick opacity changes

To change the opacity of the currently active tool, use the number keys on your keyboard. Pressing 1 will give you 10 percent; 3 gives you 30 percent; 23 gives you 23 percent; and 0 gives you 100 percent.

340 Numbers on the go

Change the number settings for type sizes, adjustment percentages, scaling, and so on by using the up and down arrow keys. Using Shift with the arrow keys makes changes of larger values.

341 Hide selections and guides

The keystrokes Ctrl + H can be used to hide selection edges, text highlighting, slices for the Web, and guides. Be sure to remember that these objects are still there!

342 Remove fringes

Copy and paste an object from a light background onto a dark background and you often see a white outline. To remove this fringe, choose Layer > Matting > Defringe and use a setting of 1. The same applies for dark onto light.

343 Instant digital polarizing filter

Make a selection of the blue section of the image and then choose Layer > New Fill Layer > Solid Color. Set the mode to Color Burn and then click OK. Choose a shade of gray from the color picker that pops up. The darker the gray, the stronger the polarizing effect.

344 Copy all layers in a selection

Holding the Shift key down while copying a selection (Ctrl + C) will copy all the layers in the selection. Alternatively, you can create the same result by making the selection and then choosing Edit > Copy Merged.

345 Make exact fits

Holding down the Shift key while dragging selections or layers between images of the same dimensions will keep the transferred components in exactly the same position. If the documents are different sizes, using the Shift key will mean that the copied component will be placed in the center of the new document.

346 Watch out for slicing

If a "01" appears in the upper left corner of your open Photoshop documents, then you have clicked on the Slice tool (perhaps accidentally). To hide the slices display select View > Show > Slices.

347 Mac translator for keystrokes

Windows	Shift	Alt	Ctrl
Macintosh	Shift	Option	Apple

348 Multiple filters

You can apply the last-used filter again to your image by clicking Ctrl + F. This shortcut uses the same settings that were applied the first time. To bring up the dialog to allow a change of settings, hold down the Alt key as well as Ctrl + F.

349 Put the action back!

If the shutter speed you have used to photograph action has left things looking too static, try adding some motion blur back to the picture using the Filter > Blur > Motion Blur. Remember to adjust the angle to align it with the movement.

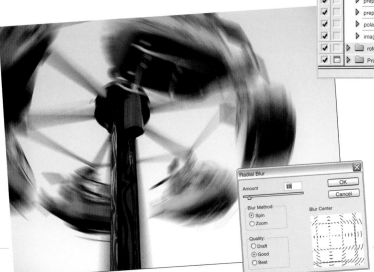

350 Automate your most used techniques

Use the Photoshop Actions feature to record the various steps in your favorite technique. When you next want to create this effect, simply open the image and play back the action from the Actions palette.

Ageing your photographs

Many people would say that old photographs have a certain magic. It is hard to pin down exactly why we are so fascinated by these aged images–it may simply be nostalgia, the knowledge that you are holding a piece of captured history in your hands; or it may be the fact that these images look so different from their modern counterparts. Many contemporary shooters use a range of digital techniques to capture this look and feel in their pixel-based photographs. Use these tips to let your images appear to grow old gracefully.

351 Create a vignette-style effect

Make an oval selection using the Elliptical selection tool from the Elements toolbox. Feather the selection (Select > Feather) to make the transition between the selected and nonselected areas more gradual. Invert the selection (Select > Inverse) and then press the Delete key to remove the background.

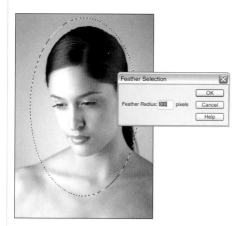

352 Sepia-tone the image

One of the dominant characteristics of many older images is their brown monochrome or sepia-toned appearance. A digital simulation of this technique can be obtained by opening the Hue/Saturation feature (Enhance > Adjust Color > Hue/Saturation), ticking the Colorize option and then moving the hue slider to a value of about 30. The strength of the color can be changed by sliding the Saturation slider.

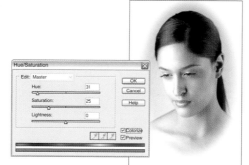

353 Convert an old photo frame to digital

Photograph an old photo frame. The one in the example was captured using windowlight directed from the top of the picture. You can use a scanner to capture the frame, but you will not get the same texture as the light is reflected straight from the surface rather than at an angle.

354 Change the cutout shape

Change a circular cutout to suit an oval-shaped picture by making a feather selection of the cutout and then copying (Edit > Copy) and pasting (Edit > Paste) the selection. Now use the free transform tool (Image > Transform > Free Transform) to make the circle taller. Double-click to apply.

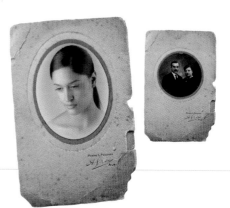

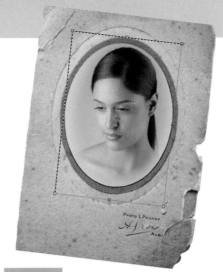

355 Add a picture to the frame

Flatten the picture (Layer > Flatten Image) and then select the inside of the cutout using a Lasso. Feather the selection by 1 pixel. Save the selection (Select > Save Selection). Open your picture and select the whole image (Select > All) and copy (Edit > Copy) the picture to memory. Click onto the frame background document and make sure that the cutout selection is still active. Now select the Paste Into option from the Edit menu (not the Paste option). Straight after you paste the portrait into the cutout, select the Free Transform feature using the shortcut keys Ctrl + T, allowing you to manipulate the size of the portrait to suit the cutout. Double-click to apply.

356 Match textures

Sometimes a montage can look obvious if the texture of the two parts differs. To match these , select a portion of the picture surround and then copy and paste this into a new Photoshop document. Save the texture as a PSD file. Reload the original selection made for the cutout (Select > Load Selection). Now apply the saved, copied texture to the portrait area using the Load Texture option in Texturizer.

357 Constraining in transformations

To ensure that the picture you "paste into" the frame selection retains the same proportions during your free-transformation changes, hold down the Shift key while dragging a corner handle.

358 Disguise size differences

In the example, the portrait picture was originally larger than the surround therefore may appear sharper in the final composite. Try softening the portrait a little using the Gaussian blur (Filter > Blur > Gaussian).

359 Fade the edges of a picture

Make a rough selection of the edges of the image using the Lasso—select the image first and then invert it (Select > Inverse). Feather the selection (Select > Feather) to smooth the transition of the ageing effect, then choose the Photocopy filter (Filter > Sketch > Photocopy). With the preview set to show the selected area, adjust the sliders until the edges of the image show a faded look. Click OK.

360 Capture some texture

Rather than trying to create your own textured background digitally, try photographing a crumpled piece of paper. Use side- or toplighting to provide the best surface texture.

361 Select the texture

When you want to combine the crumpled paper with another image, open the picture and select the paper background. Feather the selection by 1 pixel. Be sure to deselect any holes or torn sections. Save the selection.

362 Reveal texture from a separate layer

To reveal the texture of the crumpled paper layer through the picture layer above, change the layer mode of the upper layer to Multiply. The texture and crumples will show through.

363 Combine picture and paper

Open a picture and copy (Edit > Copy) the whole photo. Change to the crumpled-paper background picture and with the selection active, paste the copied portrait (Edit > Paste). If the image doesn't quite fit, use the Free Transform feature (Image > Transform > Free Transform) to resize the portrait so that it covers the whole of the paper. Double-click to apply.

364 Shape the picture to fit the paper

If the picture layer needs to be trimmed to fit the shape of the crumpled paper, create a selection of the paper's edges or load the selection that you saved previously. Now invert the selection (Select > Inverse) and press the Delete key. This will remove the edges of the portrait so that it is the shape of the background.

365 Extra texture control

Changing the blend mode of the upper picture layer allows the texture to show through, but gives the user little control over the strength of the effect. To change the strength, add a Levels adjustment layer (Layer > New Adjustment Layer > Levels) between the paper background and the picture layers. Now you can control the contrast and lightness/darkness via the sliders.

366 Age the colors

Old photographs often appear a yellow or reddish brown, thanks to oxidizing chemicals in the print. You can add these characteristics with yet another Levels adjustment layer, this time at the top of the layer stack. To add some yellow to the highlight end of the tonal scale, select the blue channel from the dropdown menu in the Levels dialog and drag down the white-point output slider. To add red, select the red channel and move the middle input slider to the left. Click OK.

Cropping and resizing images

Cropping or removing unwanted parts of a picture is a skill that most digital photographers use regularly. Photoshop and Photoshop Elements have a special feature called the Crop tool for this task.

367 Using the Crop tool

Cropping is a simple matter of drawing a rectangle around the parts of the picture that you wish to keep, leaving the sections that will be removed outside of the marquee. Areas outside the cropping marquee are shaded a specific color (usually semi-transparent black) for preview purposes.

369 Customize the crop

Photoshop and Elements shade the area of the picture that is to be removed in the crop. You can alter the color and opacity of this shading (called the "shield") using the settings in the Option bar.

370 Set a specific size

You can make a crop of a specific size and resolution by adding these values to the Crop tool's Options bar before drawing the marquee. Using this feature, you can crop and resize in one step. With the dimensions and resolution values set when you click and drag the Crop tool, it will only draw rectangles the size and shape of these values.

368 Fine-tune the crop

To help with fine adjustments, the edges and corners of the cropping marquee contain handles. The marquee can be resized or reshaped at any time by clicking and dragging one.

371 Prepare a photo for a particular print size

When you crop using the Size and Resolution options, Photoshop or Elements will automatically prepare the picture. In the example below, the image is to be printed on a sheet of 10 x 8in paper at a resolution of 200 pixels per inch (ppi). Cropping with these values accurately prepares the picture for print.

372 Check crop sizes

To check the size and resolution of crops, select the Image > Resize > Image Size dialog and confirm the values in the Width, Height, and Resolution boxes.

373 Clear crop settings

The settings entered into the Width, Height, and Resolution sections of the Crop tool Options bar remain until you click the Clear button.

374 Cropping without the Crop tool

A final on-the-fly cropping technique makes use of a drawn rectangular marquee to define the size and shape of the crop. After drawing the marquee, select the crop item from the Image menu.

375 Autosize from one picture to another

If you want the dimensions and resolution of an image to become the settings used to crop a second picture, select the original and click the front image button. The picture's characteristics are input into the settings area of the Crop tool ready for you to apply them to another photograph.

Controlling shadows and highlights

Shadows and highlights can be a challenge for any photographer. Use these simple tips
to add detail and dynamism to two elements that are vital for good photography.

376 Lighten shadows, darken highlights

The Shadow/Highlight feature provides a great way to
lighten the shadows or darken the highlights in a picture.
Although similar effects could be achieved with the Curves
feature, many users will find this interface easier to use.

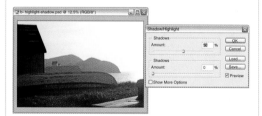

377 More shadow and highlight control

Selecting Show More Options provides more control over
the changes, including extra sliders for both highlight and
shadow adjustment and control of midtone contrast and
color saturation. The tonal width setting adjusts the range
of values that are changed by the slider. Lower values
change a smaller spread of tones.

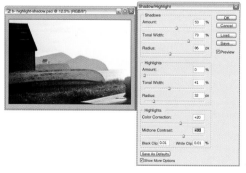

378 No more haloes with Shadow/Highlight

Use lower tonal width values in the Shadow/Highlight
feature to reduce the halo effects that sometimes appear
around strong dark and light edges.

Shadow/Highlight		
Shadows		OK
Amount: 100 %		Cancel
Tonal Width: 22 %		Load...
Radius: 30 px		Save...
		☑ Preview
Highlights		
Amount: 0 %		

Understanding channels

Channels are the way in which your image-editing program understands and manages how color is represented, which varies depending on whether your image is destined for viewing onscreen, or as a print. Learning how your software separates colors into their constituent elements opens up a whole new world of creativity...

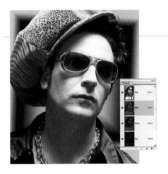

381 Channels and file size

Changing the number of channels also affects the file size of a picture. Four-channel CMYK images are bigger than three-channel RGB pictures, which are roughly three times larger than single-channel grayscale images.

379 What are channels?

Channels are the way in which the color in an image is represented. Most images that are created by digital cameras are made up of Red, Green, and Blue (RGB) channels. In contrast, pictures that are destined for printing are created with Cyan, Magenta, Yellow, and blacK (CMYK) to match the printing inks.

382 Changing color mode

Though most editing and enhancement work can be performed on the RGB file, the digital photographer may sometimes need to change color modes. There is a range of conversion options located under the Mode menu (Image > Mode) in Photoshop.

384 Color modes and channel options

• RGB: Consisting of Red, Green, and Blue channels, most digital camera and scanner output is in this mode.
• CMYK: Designed to replicate the ink sets used to print magazines, newspapers, and books, this mode is made from Cyan, Magenta, Yellow, and blacK channels.
• LAB: Consisting of Lightness, A color (green-red), and B color (blue-yellow), this mode is used by professionals when they want to enhance details without altering color. By selecting the L channel and then performing their changes, only the image details are affected.
• Grayscale: Consisting of a single black channel, this mode is used for monochrome pictures.

380 Viewing channels

Many image-editing programs contain features designed for managing and viewing the channels in your image. Photoshop uses a separate Channels palette (Window > Channels). This breaks the full color picture into its various color parts.

383 Should you change channels for print?

For most image-editing and enhancement tasks, RGB color mode is all you will ever need. A question often asked by photographers is "Given that my ink-jet printer uses CMYK inks, should I change my photograph to CMYK before printing?" Logic says yes, but practically speaking this type of conversion is best handled by your printer's driver software. Most modern desktop printers are optimized for RGB output even if their ink set is CMYK.

Using Lens Blur
The demand for shallow depth of field effects has been so great in the last few years that dedicated digital photography fans have developed a variety of multiselection techniques for creating digital versions of this camera feature. Photoshop includes a Lens Blur filter that merges many of these techniques into one useful tool.

385 Restrict the blurred area

To restrict the area that is blurred and to make the transition between sharp and blurred areas more gradual, create a feather selection. In the example, an elliptical selection was created, rotated (Select > Transform Selection) so that it lay along the stem of the asparagus, feathered (Select > Feather), and then saved for use.

386 Load a selection in Lens Blur

Select the preview option in the Lens Blur dialog and set the depth map to a previously saved selection. In the example, to ensure that the area around the asparagus is blurred, the selection is inverted by choosing the Invert option.

387 Control blur in the picture

Experiment with adjusting the strength off the blur using the Radius slider and preview the effect until you become more expert at using it.

388 Disguise the effect of blurring

To help disguise the smoothing effect caused by the blurring, magnify the preview to 100 percent and then add some noise using the controls in the bottom right of the dialog. The trick is to balance the added noise with the look and feel of the digital grain of the rest of the image.

389 Beyond a simple Selection Blur

More complex blurring options are available when you start to use sophisticated depth maps based on gradient masks. In this approach, the level of sharpness relates directly to the density of the mask. Black mask areas remain sharp; white portions remain completely blurred; and gray parts are partially blurred depending on the gray's brightness.

High-bit files

Many different types of photographic hardware can capture "high bit" image files. As resolution and channel management prepares to take another giant leap ahead in terms of quality, then you need to get to grips with how it all works. So here are some tips for understanding and managing high-bit files.

390 High resolution is not the only factor

Most of us are very aware of the impact that resolution has on the quality of our images. But high resolution is only half the image quality story. The number of colors in an image is also a factor that contributes to the overall quality of the photograph.

391 Beyond 8 bits per channel

Many modern cameras and scanners are now capable of capturing 16 bits per channel; this is known as "high bit" capture. This means that each of the three colors can have 65,536 different levels and the image 281,474,976 million colors. More colors equals better quality.

392 The more colors, the better

Capturing images in High-bit mode provides a larger number of colors for your camera or scanner to construct your image with. This in turn leads to better color and tone in the digital version of the continuous-tone original.

393 High beats low

Global editing and enhancement changes made to a high-bit file will always yield a better quality result than when the same changes are applied to a low-bit image.

394 No poster pin-ups

Major enhancement of the shadow and highlight areas in a high-bit image are less likely to produce posterized tones than they would in a low-bit version.

395 A new level of image

More subtle changes and variations are possible when adjusting the tones of a high-bit photograph using Levels or Curves than is possible with low-bit images.

396 All about bits...

Each digital file you create (capture or scan) is capable of representing a specific number of colors. This capability, usually referred to as the "mode" or "color depth" of the picture, is expressed in terms of the number of "bits."

397 Multimillion hues

Most images these days are created in 24-bit mode (8 bits per color channel). This means that each of the three-color channels (red, green, and blue) is capable of displaying 256 levels of color (or 8 bits) each. When the channels are combined, a 24-bit image can contain 16.7 million hues.

Grayscale conversion

Despite the fact that some digital cameras give you the option to capture pictures in Grayscale mode, most professionals shoot in full color and then convert. But conversion to grayscale is not as simple as it might seem. As with many digital processes, there are several ways to do it. Here are some of the popular approaches, plus an advanced process from Russell Brown, one of the original gurus of Photoshop.

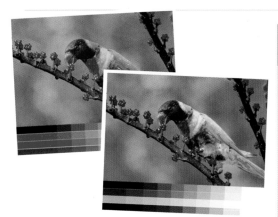

398 Change to Grayscale mode

This is probably the most popular way to convert your color pictures, but often results in a flat, low-contrast picture.

Photoshop/Photoshop Elements

• **Step 1 –** Select the Grayscale option from the mode section of the image menu.

• **Step 2 –** Click OK to the "discard color information?" question.

399 Desaturate the picture

Use the Desaturate command when you want to keep the RGB structure but just remove the color. This can leave you with an image where there is little distinction between colors such as red and green.

Photoshop

• **Step 1 –** Select Image > Adjustments > Desaturate.

Photoshop Elements

• **Step 1 –** Select Enhance > Adjust Color > Hue/Saturation.

• **Step 2 -** Drag the Saturation slider to -100 to remove the color.

400 Desaturate the RAW file

If you shoot in RAW, you can apply this desaturation technique by making the conversion while in the Camera Raw dialog in Photoshop or Photoshop Elements.

Photoshop/Photoshop Elements

• **Step 1 –** Open the RAW file into Photoshop/Photoshop Elements. This action automatically displays the picture inside the Camera Raw feature.

• **Step 2 -** Drag the saturation slider in the adjust panel to -100 to remove the color.

401 Convert using LAB mode

This change separates the color from the detail (tone) in the picture. The L channel is then used as the basis for the creation of the new grayscale picture.

Photoshop

• **Step 1 –** With the image open in Photoshop, change the mode of the picture to LAB by selecting Image > Mode > LAB Color.

• **Step 2 –** Now display the Channel palette (Window > Channels) and select the L channel (or press Ctrl + 1).

• **Step 3 –** Select all of the layer (Ctrl + A) and then copy this selection (Ctrl + C) to store the tonal details in the computer's memory.

• **Step 4 –** Create a new document (Ctrl + N) and paste in the copied layer (Ctrl + V).

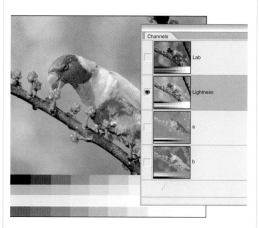

402 Use the Channel Mixer

The Channel Mixer offers effective grayscale conversion that allows the user to adjust the way that different colors are converted to gray tones.

Photoshop

• **Step 1 –** With the image open in Photoshop, add a Channel Mixer Adjustment Layer to the document (Layer > New Adjustment Layer > Channel Mixer).

• **Step 2 –** Select the Monochrome option at the bottom of the dialog. This allows you to convert to grayscale while varying the underlying color components of Red, Green, and Blue.

• **Step 3 –** Alter each of the three color sliders, ensuring that the total value of their settings adds up to 100 percent.

• **Step 4 –** You can change the brightness of the overall image by moving the constant slider. Click OK to apply the conversion.

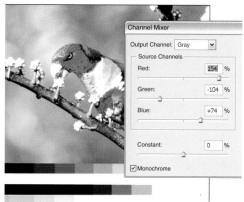

403 Russell Brown's technique

This technique uses the Adjustment layers in Photoshop/ Photoshop Elements as a way to convert the image to black and white, while controlling how the colors are represented in the grayscale. It leaves the original image unchanged ("non-destructive editing").

Photoshop/Photoshop Elements

• **Step 1 –** Make a new Hue/Saturation layer above your background. Set the mode of the adjustment layer to color. Label this layer "Filter."

• **Step 2 –** Make a second Hue/Saturation adjustment layer above the filter layer and alter the settings so saturation is -100. Call this layer "Black and White Film."

• **Step 3 –** Next, double-click on the layer thumbnail in the filter layer and move the hue slider. This changes the way that the color values are translated to black and white.

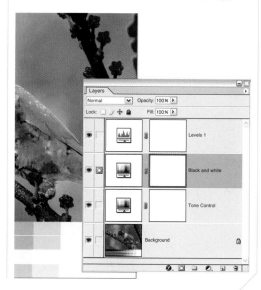

Using Match Color

The Match Color command in Photoshop can be used to unify the color of two images that were shot in the same location at the same time but resulted in pictures containing different dominant color casts.

404 Match the whole or just a part

With this feature, you can match the color scheme of whole pictures, individual layers, or selections between images. Start the process by making a basic selection in the source image that roughly corresponds to the image detail of the destination file.

405 Make the match via a selection

With a selection active in the source image, click onto the destination picture (the one where the color is going to change) and choose the Image > Adjustments > Match Color feature. Select the source image from the dropdown menu in the image statistics section of the dialog and make sure that the Use Selection in Source to Calculate Colors option is ticked. Move the Luminance and Color Intensity sliders to edit the mix.

407 Reduce the strength of the changes

The Fade slider can be used in a similar way to the familiar Fade Filter command: it can be employed to alter the strength of the adjustment applied to the image.

406 When to match all or part of the picture

In the example, using the color characteristics of the whole of the source image results in a matched color change that is too light, yellow, and flat. In this case, a selection of the critical areas in the source picture is the best approach. In your own pictures, try using the whole image as the source to begin with and then switch to a selected area if the results are not what you expect.

Creating panoramas

The Photomerge feature in Photoshop and Photoshop Elements create fantastic panoramic pictures by stitching together overlapping pictures to form a single image. These tips will give you a head start when producing your own panoramic vistas.

408 Quickly add photos by multiselecting

To start to stitch a series of images with Photomerge, you can multiselect the source pictures from inside the CS file browser, the Bridge application in CS2+, or the Organize Workspace in Photoshop Elements. After making the selection, you can choose Photomerge from Automate or the Photoshop Tools menu.

409 Add folders of source pictures

Alternatively, if you store your panorama source pictures in a single folder, you can add the folder contents directly in the Photomerge dialog. Start the feature and use the Browse button to locate and select the folder that contains the source pictures.

410 When automatic placement fails

When the source images are first opened into Photomerge, it will try to place them automatically. With some pictures the program will not be able to overlap them automatically. In these cases, a warning dialog will display and the pictures be placed at the top of the screen where you can organize them manually. Click and drag the pictures into the workspace, positioning them so that edge details align.

411 Get help with alignment

With the Snap to Align option checked, the program will match the edge details automatically. This helps when positioning individual images that have been selected and moved or rotated using the tools in the toolbar.

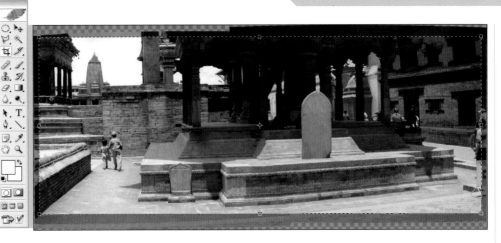

412 The Perspective option

Using the Perspective option distorts the shape of the pictures to fit the perspective or vanishing point of a chosen image. This option can help with creating better blends between photos that have been taken with wideangle lenses. To set, select an image in the composition and then choose the Perspective option.

414 Remove jagged edges in the final panorama

With the completed picture open in Photoshop, use the Crop tool to remove any jagged edges (jaggies) from the picture. This picture is now a standard Photoshop file and so can be edited and enhanced as normal.

413 From perspective to photo shape

To remap the picture back to a rectilinear shape and ensure the best transition between successive source images, select the Cylindrical Mapping and Advanced Blending options. Click the preview button to display a predicted result. Click OK to generate the panorama as a Photoshop file.

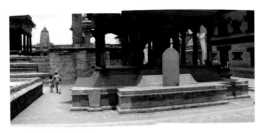

415 Restore detail in missing areas

Often you can restore the missing detail in the border areas of a completed panorama by cloning in texture from other areas of the photograph. This is an alternative to cropping.

416 Keep the source pictures separate

If you want to maintain the individual images as separate layers in the final Photoshop document, click the Keep as Layers option in the Photomerge dialog before processing.

Converting RAW Files

Many cameras contain options for capturing in RAW mode, which, as the name suggests, is the unadulterated information captured by the camera. Photoshop and Photoshop Elements contain a built-in RAW editor, called Camera Raw. Here are some tips...

419 Adjust tonal values

Next, adjust the tones in the picture with the Exposure, Shadow, Brightness, and Contrast sliders. Start with the uppermost control (Exposure) and adjust each slider in turn, ensuring that no details are lost during the process. Use the histogram to watch how the changes you make affect the spread of tones in the image.

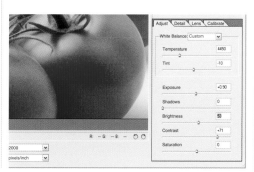

420 Make the photo clearer

The final step in the process is to adjust the sharpness of the picture. Click on the Detail tab in the Settings part of the dialog. Make sure that the picture is displayed at 100 percent before adjusting the Sharpness, Luminance, and Color Noise sliders. Click OK to complete the conversion.

417 Start the Camera RAW editor

Selecting any RAW file from Photoshop's file browser, Bridge, or the Organizer workspace in Photoshop Elements will activate the Camera Raw editor. The dialog contains a preview image and a set of controls that govern the conversion from RAW data to an editable format.

418 Color temperature in White Balance

Start the conversion process by adjusting both the Temperature (big changes) and Tint (fine-tuning) sliders in the White Balance options. If your picture has a neutral tone present, select custom from the dropdown menu and use the Eyedropper to click on this picture part. The editor balances the color so that this area has equal parts of red, green, and blue.

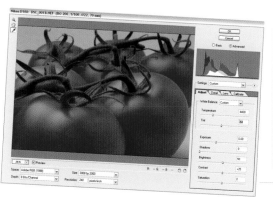

421 Basic and Advanced modes

In CS versions of Photoshop, the plugin can be used in two different modes: Basic, and Advanced. By default, the feature opens in the Basic mode. Selecting Advanced mode gives access to additional controls to adjust and correct lens faults such as vignetting and chromatic aberrations, and to fine-tune color balance.

Digital toning

One of the great techniques film-based printing was when a black-and-white print was transformed into something special by passing the photograph through a toning bath. In the most popular of these processes, sepia toning, the grays of the original photo were changed to subtle shades of brown. Toning was a way that photographers added "personality" to their pictures. Digital has not affected people's desire to produce pictures in a range of toned finishes.

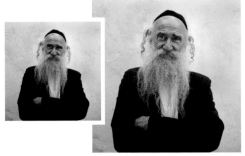

423 Control the toning effect

The Hue setting acts as a color selector with which you can move through the spectrum of tints. The Saturation control alters the color strength. Moving left increases the selected color's vibrancy; move to the right and eventually you end up with a grayscale picture.

422 Basic digital toning

Photoshop and Elements users should go straight to the Hue/ Saturation dialog, located in the Image > Adjust or Enhance > Adjust Color menus. Selecting Colorize places the feature in Tinting mode, which swaps grays for shades of your choice of colors.

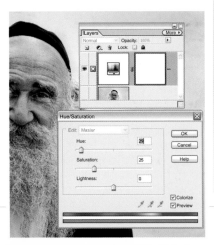

424 Prepare a grayscale file for toning

To tone a black-and-white image, you must first provide the option for the file to store color. As most black-and-white pictures start life in the grayscale mode, the first step is to convert the photo to RGB mode via the Image > Mode > RGB Color menu item.

425 Nondestructive toning

Wherever possible, you should apply changes to a photo via an Adjustment layer rather than directly to the picture. This way, the original picture remains intact.

426 Hue/Saturation layer

With toning it is better to add a Hue/Saturation Adjustment layer by clicking on the Create Adjustment Layer icon in Layers than using Image > Adjustments > Hue/Saturation.

427 Brighten the toned picture

Don't use the Lightness slider in the Hue/Saturation dialog to make any brightness changes; instead, employ a Levels adjustment layer after the toning step is completed.

428 Toning recipes

Use this visual guide and Hue/Saturation feature settings to help predict the color of your toned prints.

429 Tinting highlights

Now let's play with the image a little more and tone the shadows and highlights different tints. This process, split toning, also finds its roots in traditional photographic printing, but unlike its counterpart, the digital equivalent is quick, predictable, and easily controllable.

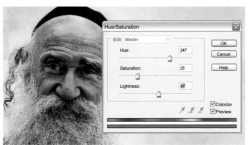

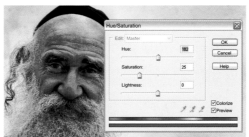

430 Split toning basics

The technique detailed here uses the Color Variations feature in Photoshop Elements (Variations in Photoshop). By selecting Highlights or Shadows in the dialog and then intentionally adding a cast to the picture by selecting a colored thumbnail, it is possible to introduce a tint to specific tonal ranges of your black-and-white photo.

431 Tone with duotones

In Photoshop

• **Step 1 –** Convert color image to grayscale.
Image > Mode > Grayscale.

• **Step 2 –** Switch to Duotone mode.
Image > Mode > Duotone.

• **Step 3 –** Change type from Monotone to Duotone
(or Tritone or Quadtone).

• **Step 4 –** Double-click in the second ink color area
to select another color.

• **Step 5 –** Double-click in the Curve area to adjust the
application curve. Click OK to finish.

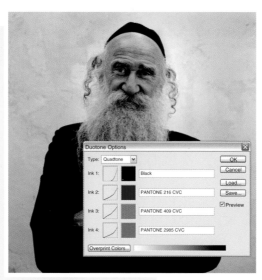

432 Beyond duotones

Tritones and quadtones extend your creative possibilities
even further by adding extra inks into the equation. As you
might imagine, with tritones, you mix three ink colors; with
quadtones you mix four to form the tonal scale used to
represent the monochrome picture.

433 Start with the simplest approach

If this all seems a little too complex, then try the Duotone
presets that come bundled with Photoshop. Here, the colors
and curve shapes have been designed to provide images
with smooth and even transitions between tones and hues.
Find these digital toning recipes in the Presets folder.

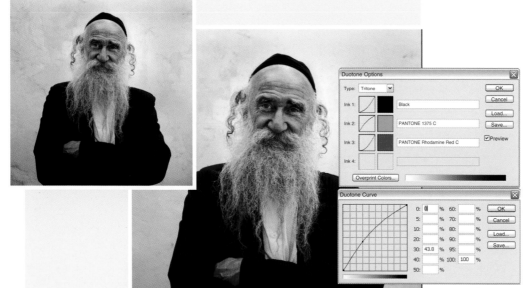

Dodging and burning

Most of us are familiar with the Dodge and Burn tools our image-editing packages. These features are a great way to control the levels of brightness of specific areas in our images. In so doing, the photographer is able to guide the viewer's eye away from some image parts and toward others. However, there are often some more sophisticated and rewarding means of making detailed changes of this nature.

434 Adjust tones without Dodge and Burn

A flexible approach involves carefully made, soft-edged selections and the tone-changing abilities of Levels. This technique offers more precise control over how dark or light image parts become. It works with highlights, midtones, and shadows independently, or in combination.

435 Mask areas from tonal changes

Using the Selection brush tool in Photoshop Elements set to Mask, or the Quick Mask mode in Photoshop, paint over the object that needs to be protected from the tone changes with a soft-edged brush. The red tone indicates the masked areas. Work the brush around the edge of the subject and then fill in the center. Be sure to paint all areas that you don't want to change!

436 Save the mask for later

With the mask complete, Elements users can save the selection using the Select > Save Selection menu command. Photoshop users need to switch back to standard editing mode before saving the selection. This step allows the selection to be loaded again later.

The Dodge (left) and Burn (right) tool options as they appear on the Photoshop CS2 toolbar.

437 Apply changes via the selection/mask

Create a Levels Adjustment layer (Enhance > Adjust Brightness/Contrast > Levels or Image > Adjustments > Levels). Notice that the mask/selection disappears and the areas that were not masked become selected. It is these areas that will be adjusted with any changes that you make in the Levels dialog.

438 Burning with Levels

To darken midtones in the selected area, move the Midtone input slider to the right. This action does not affect the black and white tones in the image, just the midtones. To darken the highlight areas, move the White Output slider to the left. This darkens the white tones, effectively burning in the highlights.

439 Dodge with Levels

To lighten the midtone values of the selected area, move the Midtone input slider to the left. To lighten the shadow or black tones in the image, drag the Black Output slider to the right.

440 Soften the transition between changes of tone

By using a soft-edged brush to paint the mask, create a gradual transition between the selected and nonselected areas. This is more natural than a sharp knife edge that occurs when using Polygon, Lasso, or Marquee tools (if they are not feathered, that is).

Using Layers

Many image-manipulation packages use the layers model as a way of extending the editing and enhancement options available to users. Being able to separate different components of a picture means that these pieces can be moved and edited independently. This is a great advantage compared to flat file editing.

Create a new layer

441 What is a layered file?

A special file type is needed if your edit features are to be maintained after a layered image is saved and reopened. In Photoshop, the PSD format supports all layer types and maintains their editability after saving and reopening. Other packages also use their own proprietary format to store their layered images. Common file formats such as JPEG and TIFF don't generally support these features. They flatten the image layers, making it impossible to edit individual image parts later.

442 Adding layers

When a picture is first downloaded from your digital camera or imported into Photoshop, it contains a single layer. By default, the program classifies the picture as a background layer. You can add extra "empty" layers to your picture by clicking the New Layer button at the bottom of the Layers palette (or top for Elements users) or choosing Layer > New > Layer. The new empty layer is positioned above your currently selected layer.

443 Automatically adding new layers

Some actions, such as adding text, automatically create a new layer for the content. This is also true when adding Adjustment and Fill layers to your image, and it occurs when selecting, copying, and pasting parts.

444 Viewing layers

The Layers palette in both Photoshop and Photoshop Elements displays all the layers contained in a document and their settings in the one dialog box. If this palette isn't already on screen when opening the program, choose the option from the window menu (Window > Layers).

445 The layer stack

All individual layers are displayed, one on top of each other, in a "layer stack." The image is viewed from the top down through the layers. When looking at the picture onscreen, we see a preview of how the image looks when all the layers are combined. Each layer is represented by a thumbnail on the right and a name on the left.

446 Name those layers!

By default, each new layer is named sequentially (layer 1, layer 2, layer 3, etc). This is fine when your image contains a few different picture parts, but for more complex illustrations it is helpful to rename the layers to match their content.

447 Editing the contents of layers

You can edit or enhance only one layer at a time. To select the layer that you want to change, you need to click on the layer. At this point, the layer will change to a different color from the rest in the stack. This layer is now the selected layer and can be edited in isolation from the others.

448 Hiding layers

Layers can be turned off by clicking the eye symbol on the far right of the layer so that it is no longer showing. This action removes the layer from view but not from the stack. You can turn the layer back on again by clicking the eye space.

449 Manipulating layers in the stack

Layers can be moved up and down the layer stack by clicking and dragging. Moving a layer upward will mean that its content may obscure more of the details in the layers below. Moving downward positions the layer's details further behind the parts of the layers above.

450 Layer shortcuts

- To access layers options: click sideways triangle in the upper right-hand corner of the Layers palette.
- To change the size of layer thumbnails: choose Palette Options from the Layers palette menu and select a thumbnail size.
- To make a new layer: choose Layer > New > Layer.
- To create a new Adjustment layer: choose Layer > New Adjustment Layer and then select the layer type.
- To create a new layer set: choose Layer > New > Layer Set.
- To add a style or effect to a layer: select the layer and click on the layer styles button at the bottom of the palette.

451 Moving layer contents

You can reposition the content of any layers (except background layers) using Move. Two or more layers can be linked so that when the content of one layer is moved the other details follow precisely. Click on the box on the right of the eye symbol in the layers to link together. A chain symbol indicates that the layer is linked with the selected layer.

452 Deleting layers

Unwanted layers can be deleted by dragging them to the trashcan icon at the bottom of the Layers palette. This removes the layer and its contents from the stack.

453 Layer effects

In earlier versions of Photoshop, creating a drop-shadow edge to a picture was a process that involved many steps. Thankfully, the latest versions of the program includes this as one of the many built-in effects, along with inner shadows, outer glows, inner glows, bevels and embossing, satins, plus color, gradient, and pattern overlays.

454 Adding layer effects

Add effects by clicking on the Layer Style button at the bottom of the Layers palette, or choose Layer Style from the Layer menu. The effects added are listed below the layer in the palette. You can turn effects on and off using the eye symbol and edit settings by double-clicking on them in the palette.

455 Layer opacity

As well as layer styles, or effects, the opacity of each layer can be altered by dragging the opacity slider down from 100 percent to the desired level of translucency. The lower the number, the more detail from the layers below will show through. The Opacity slider is located at the top of the Layers palette and changes the selected layer only.

456 Layer blending modes

On the left of the opacity control is a dropdown menu containing a range of blending modes. Switching to a different blending mode alters the way in which the content of each layer interacts.

457 Layer sets

Layer sets, or Groups as they are known in Photoshop CS2 onward, are groups of layers organized into a single folder. Placing all the layers of a single picture part into a set makes these layers easier to organize.

458 Layers into sets

Layers can be moved into the set by dragging them onto the set's heading. To create a layer set, press the New Set (New Group) button at the bottom of the palette or choose Layer > New > Layer Set (Layer > New Group).

459 Layer types

• Image layers: This is the most basic and common layer type containing any picture parts or image details. An image can only have one "Background" layer.
• Text layers: These layers allow the user to edit and enhance the text after the layer has been made.
• Adjustment layers: These layers alter the layers that are arranged below them in the stack. They act as a filter through which the lower layers are viewed.

460 Enhancements

You can use Adjustment layers to perform many of the enhancement tasks that you would normally apply directly to an image layer without changing the image.

Correcting common lens problems
In the rush for manufacturers to offer longer zooms and wider angles at lower prices, pictures can exhibit different types of lens distortion effects. The following tips will soon have your pictures free of some of the common forms of distortion caused by certain types (not to mention price points) of lens.

461 Barrel distortion

Barrel distortion is usually associated with images that are photographed with extreme wideangle lenses:
• Straight lines near the edge of the frame appear bent
• The whole image appears to be spherical or curved outward
• Objects that are close to the camera appear very distorted.

462 Pincushion distortion

The opposite effect to barrel distortion can be seen in images that are created with some telephoto lenses:
• The image seems to recede into the background
• Straight lines that appear near the edge of the frame are bent inward
• The whole image appears to be projected onto the inside of a ball (curved inward).

463 Vignetting

Vignetting, the darkening of the corners of digital images, is another problem that can occur when using extreme wideangles with poorly designed lens shades. Ensure that you don't use the wrong lens hood, or in the case of a multifit rubber lens hood, check that it is set for a longer focal length.

464 Correcting distortion with Photoshop

Try using the Spherize filter (Filter > Distort > Spherize), to make simple corrections. Moving the slider to the right balloons the picture, correcting pincushion distortion, sliding the control to the left reduces barrel distortion.

465 Give yourself space!

To overcome these problems and apply the changes to the entire picture, you will need to add some space around the image before applying the filter. Use the following steps to correct photos that suffer from lens distortion.

466 Correcting barrel distortion

• **Step 1:** Open the example image. Next, select the Crop tool and click and drag the marquee so that it covers the whole of the picture. Now click on the marquee corner handles in the top left and bottom right and drag these outward beyond the edge of the picture. Double-click in the center of the marquee to add the new canvas space.

• **Step 2:** Open the Spherize filter (Filter > Distort > Spherize) and adjust the magnification of the thumbnail so that all of the image can be seen. Drag the amount slider to the left to remove the barrel distortion. Continue the adjustment until the ballooning effect is no longer evident. Click OK to apply.

• **Step 3:** Select the Crop tool and after drawing the crop marquee around the picture click on the perspective setting in the tools option bar. Click and drag the top corner handles inward until they are parallel to building parts that should be vertical. Double-click in the center of the marquee to crop and correct perspective .

467 | Correcting pincushion distortion

• **Step 1:** Open the example image. As before, select the Crop tool and click and drag the marquee so that it covers the whole of the picture. Now click on the marquee corner handles in the top left and bottom right and drag these outward beyond the edge of the picture. Double-click in the center of the marquee to add the new canvas space.

• **Step 2:** Open the Spherize filter (Filter > Distort > Spherize) and adjust the magnification of the thumbnail so that all of the image can be seen. Drag the amount slider to the right to remove the pincushion distortion. Continue the adjustment until the edges of the card are no longer bent. Click OK.

• **Step 3:** Select the Crop tool and after drawing the crop marquee around the picture, click outside the marquee and drag to rotate the marquee until its edges are parallel to the card's sides. Double-click in the center of the marquee to crop and rotate the photo.

468 Test your lens

You can make your corrections a little more accurate by getting to know your lens better to start with. Set your camera on a tripod in front of a scene that has a series of parallel lines, both horizontal and vertical. A metal fence is a good choice or a side of a building with a repeating set of evenly spaced windows. Make sure that the back of the camera is parallel to the wall or fence you are photographing. Take a series of pictures of the location at different focal lengths. Make sure that you cover the whole of the zoom range of your lens. Note down the focal lengths you use if your camera doesn't record this as part of the data saved with the picture file.

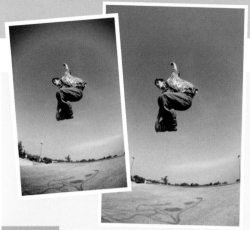

469 Be consistent!

Next, ensure that you frame each picture in the same way (yes, this means that you will need to move the camera backward and forward to account for the change in focal length) and make sure that there are straight lines near the top, bottom, and sides of the picture frame so you can spot any distortion. Preview or print the images and you now have a handy reference source that enables you to see at what point lens distortion becomes apparent.

470 Make a recipe list

Follow the steps above to correct the distortion problems in your pictures, writing down the Spherize amount used for each focal length as you go. These settings become a recipe list that can be used to adjust your images each time you shoot with a particular lens or focal length.

471 Correcting edge vignetting

Now let's turn our attention to correcting the problem of vignetting. The quick and easy method is to remove the affected portions of the picture with the Crop tool.

Though effective, this does mean that you will be losing a fair proportion of the original picture. In photographs where you have important details right to the edge of the frame, this is not a viable option.

A second solution is to use the Gradient tool set to Radial mode (circular) to create a mask the size and shape of the darkened edges. The mask is then used as the basis for a selection, which in turn is used to control a lightening of the edges via the Levels adjustment. Here's your step-by-step guide through the process so that you will soon be correcting your vignetted shots like a pro.

• **Step 1:** Start the correction process by setting up the Gradient tool in the following manner.
· Make sure that the Default foreground/background colors (black/white) are selected.
· Click on the Gradient tool in the toolbox and then select the radial option from the options bar.
· Now click the down arrow next to the Gradient preview and select the Foreground to Background option.

• **Step 2:** Click onto the Gradient preview in the Options bar to open the gradient editor. Click and drag the right-hand color stop (below) toward the center of the gradient. This will add more white at the beginning of the gradient and compress the gray and black tones to one end. This helps match the way darkening occurs at the edges of the frame.

• **Step 3:** Switch to Quick Mask mode by either clicking the Q key or the button in the toolbar. Click back onto the Gradient tool and click and drag from the center of the picture to the outside edges of the frame. Letting go of the mouse button will display the ruby mask.

• **Step 4 –** Make a selection from the mask
If the red areas of the mask do not match the darkened parts of the picture, adjust the Gradient settings and reapply the mask. Next, switch back to the standard editing, or selection mode, by clicking the Q key again. Notice that the mask is now converted to a selection of the center of the picture. Change this to the outside edges by inverting the selection (Select > Inverse).

• Step 5: Now it's time to lighten the edge portions of the picture. But first we need to hide the marching ants, or selection edges. They are a great way to see which parts of the picture will be changed, but they can get in the way of assessing how well the changes are going. Hit the Ctrl + H keys or select View > Show Selection Edges to hide the ants.

• Step 6: With the selection still active but hidden, open the Levels feature (Image > Adjustments > Levels). Any changes you make to the picture with levels will now be restricted to only the areas selected. Click and drag the midtone input slider to the left. This will lighten the edges. Continue the adjustment until the picture's edges matches the other selections of the photo. Click OK to apply and then choose Select > Deselect to remove the selection.

472 Nondestructive vignetting correction

Most professionals prefer to keep their original images intact and unaltered as much as possible. This is the case even if their pictures need a lot of work. This has led to a range of editing techniques that are referred to as "nondestructive." Based largely on the use of Layer Adjustment layers and masking techniques, changes are made to the look of the original but not the actual pixels.

473 Adjustment options

The vignetting correction technique can be adapted to this approach by selecting a Levels Adjustment layer in step 6 of the process. In this way, the edge-lighting effect is made via a masked Adjustment layer rather than to the original picture. This also means that you can adjust the Levels settings at any time later by simply double-clicking onto the left-hand thumbnail in the adjustment layer.

Output

Printing

There are several different printer technologies that can turn your digital pictures into photographs. The most popular, at the moment, is the ink-jet printer, followed by dye sublimation and laser machines. Here are some tips to help you understand the printing process and get to grips with some of the techniques and options.

474 Creating millions of colors

Get to know a bit about printing, as it will help you make better pictures. Most commercial print systems (such as those used by magazines and newspapers) use a color separation technique known as CMYK (Cyan, Magenta, Yellow, and blacK). The printer lays down a series of tiny dots of these colors. Looking at the picture from a distance, creates the illusion of many colors. This is different to the system used by your computer monitor, which is based on just three colors—Red, Green, and Blue (RGB mode).

475 Creating tone with dots

To create darker and lighter colors, the printer produces colored dots at varying sizes. The lighter tones are created by printing small dots so that more of the white paper base shows through. The darker tones in the image are made with larger dots leaving less paper showing. This system is called halftoning. In traditional printing, different dot sizes, and therefore tone, are created by screening the photograph. In desktop digital printing, different shades are created using simulated halftones.

DESKTOP PRINTING TECHNIQUES

Let's look at the three main desktop printing technologies in turn.

476 Ink-jet printers

Invest in a good desktop ink-jet printer–they are usually inexpensive. The ink-jet printer provides the cheapest way to enter the world of desktop printing. Its ability to produce great photographs is based on a combination of fine detail and seamless graduation of color and tone. The machines contain a series of cartridges filled with liquid ink. The ink is forced through a set of tiny print nozzles using either heat or pressure as the printing head moves back and forth across the paper. Do some magazine and retailer research before you buy. Does that seemingly inexpensive desktop printer require very expensive print cartridges? Do the cartridges have to be replaced very quickly? It may be more cost-effective to buy a slightly more expensive printer that works efficiently and cheaply than to go for an apparent bargain. Shop around and ask questions!

477 Dye sublimation printers

If you're serious about photography, it might be worth exploring dye sublimation printers, which create prints by using a heating element to transfer a series of overlapping transparent dyes onto a specially treated paper. This gives the image a "continuous tone" look at relatively low resolutions (300dpi) compared to ink-jets.

478 Laser printers

If you run a small or home business, have a look at laser printers. More and more are capable of producing acceptable color output. Laser printers are expensive to buy but very inexpensive to run, and for businesses that regularly produce short runs of color brochures, a color laser may be a cost-effective alternative to commercial printing. However, toner supplies might be harder to source than ink-jet cartridges, and laser printers are too expensive for light use.

Ink types

If there is one section of the digital photography process that causes confusion, it is in the area of ink sets and desktop printing. Essentially there are two different types of inks that are available: dye and pigment. Each has its own advantages and disadvantages and generally you will only have the choice of one set for your printer. If you prefer one ink type over the other, this choice will determine the printer models you can select from.

479 Dye-based inks

Most standard cartridges found in entry-level and moderately priced printers use dye-based inks. They are generally easy to use and have fewer problems with streaking, long drying times, and puddling than pigmented inks. Most dye-based ink sets are capable of a greater range of more vibrant colors than their pigment-based equivalents. The downside is that dye-based sets have a shorter lifespan than pigmented options.

480 Pigment-based inks

These products generally have a longer predicted archival life than most dye-based inks and are also more water- and humidity-resistant. They are generally available for use in high-end professional and semi-professional printers. But be warned: these ink sets can be more difficult to use and some brands do not have the same vibrancy, color, or density range as their dye-based equivalents.

481 Specialist monochrome ink sets

Some ink sets contain several different gray inks as well as black and are designed for dedicated black-and-white enthusiasts. The inks are used to print monochrome prints that are more neutral than those traditionally output from jet printers using CMYK. Such ink sets are found in photographic printers with seven or more inks.

Ink-jet paper types

There are many papers on the market that are suitable for ink-jet printing. Most can be divided into three groups: coated, uncoated, and swellable.

482 Coated papers

The coating is a special ink-receptive layer that increases the paper's ability to produce sharp photorealistic results with a wide color gamut and a rich maximum black (high D-max). Most ink-jet papers fall into this category.

483 Uncoated papers

Uncoated papers can still be used with most printing equipment, but changes in the printing setup may be necessary to get good results. Generally, standard office or copy paper as well as traditional watercolor and fine art papers fall into this category. Most photographers don't use uncoated papers because the ink soaks into the paper, producing fuzzier images.

484 Swellable papers

These papers are the most sophisticated of all ink-jet papers. As part of the printing process, a gelatin-like coating on the paper swells to encapsulate the ink. This creates an image that is much more resistant to fading than if the same image were printed on a standard coated or uncoated paper.

PAPER SURFACES

Apart from coatings, paper surface is the other major factor that distinguishes paper types. The categories of surface and their recommended usage are:

485 Glossy photographic

These are designed for the production of top-quality photographic images. These are usually printed at the highest resolution your printer is capable of and can produce photorealistic or highly saturated colors.

486 Matt/satin photographic

These papers are designed for photographic images but with surfaces other than gloss. Surfaces are specially coated so that, like gloss papers, they can retain the finest details and the best color rendition.

487 Art papers

Art papers are generally thicker-based papers with a heavy tooth or texture. Some coated products in this group are capable of producing photographic-quality images, but all have a distinct look and feel that can add subtle interest to images with subject matter that is conducive.

Paper surfaces (contd)

488 General purpose

These papers combine economy and good print quality and are designed for general usage. They are different from standard office, or copy, papers as they have a specially treated surface designed for ink-jet inks. They are not recommended for final prints, are good for proofing and drafts.

489 Speciality papers

These are either special in surface or function. The range is growing all the time and now includes such diverse products as magnetic paper, backlight films, and even metallic sheets.

Image resolution
The true dimensions of any digital file are measured in pixels, not inches or centimeters. These dimensions indicate the total number of samples of the scene (or negative/print when scanned) that were made to form the file. It is only when an image's resolution is chosen that these dimensions will be translated into a print size measured in inches or centimeters.

490 What is image resolution?

It determines how the digital information is spread over the print surface. If a setting of 100dpi is chosen, the print will use 100 pixels for each inch that is printed. If the image is 3000 pixels wide then this will result in a print that is 30in wide. If the image resolution is set to 300 dpi, the resultant print will only be 10in wide, as three times as many pixels are used for every inch of the print. The same digital file can have many different printed sizes.

491 Print size and image resolution

The following table shows the different print sizes possible when the same picture is printed at different resolutions:

Image dimensions	Print size @ 100dpi	Print size @ 200dpi	Print size @ 300dpi
640 x 480 pixels	6.4 x 4.8 inches	3.2 x 2.4 inches	2.13 x 1.6 inches
1440 x 960 pixels	14.4 x 9.6 inches	7.4 x 4.8 inches	4.8 x 3.2 inches
1600 x 1200 pixels	16 x 12 inches	8 x 6 inches	5.33 x 4 inches
1920 x 1600 pixels	19.2 x 16 inches	9 x 8 inches	6.4 x 5.33 inches
2304 x 1536 pixels	23.04 x 15.36 inches	11.5 x 7.5 inches	7.68 x 5.12 inches
2272 x 1704 pixels	22.72 x 17.04 inches	11.4 x 8.5 inches	7.57 x 5.68 inches
2560 x 1920 pixels	25.60 x 19.20 inches	12.8 x 9.6 inches	8.53 x 6.4 inches
3008 x 2000 pixels	30.08 x 20 inches	15.04 x 10 inches	10.02 x 6.66 inches

492 Changing image resolution

The resolution of the image can be changed using features like Photoshop's Image Size command (Image > Image Size). This dialog contains options for changing the overall number of pixels as well as the resolution in a picture. To ensure that you adjust only the resolution value, deselect the resample image option first and then input a new setting into the resolution section of the document size area.

493 Printer resolution

Printer resolution refers to the number of ink droplets placed on the page per inch of paper. Most modern printers are capable of 3,000 dots per inch. This value does not relate to the image resolution. It is a measure of the machine's performance, not the spread of pixels.

494 Changing printing resolution

The resolution that your printer uses is controlled via the printer driver. In this example, the setting is described as print quality and is only available once the advanced printer settings are selected.

495 Hidden print resolution control

With some printers, print resolution cannot be changed specifically and no control or menu is included for this purpose. But as print resolution is linked with the type of media or paper you print on, selecting a better quality surface will result in a better print.

496 Optimum printing resolution

Keep in mind that different printing technologies have different optimum resolutions. For example, perfectly acceptable photographic images are produced on dye sublimation machines with a printing resolution as low as 300dpi. The same appearance of photographic quality may require a setting of 1440dpi on an ink-jet machine.

497 Optimal image resolutions for print

The modern ink-jet printer is capable of amazingly fine detail. A typical photographic-quality Epson printer is able to print at 5760dpi when set on its finest settings. Logic dictates that if you were to make the best-quality print from this machine then you would need to make sure that your image resolution matched this print resolution. This may be logical but it is not practical. A file designed to produce a 10 x 8in print at 5760dpi would be about 246,000Mb in size! The answer is to balance your need for print quality with file sizes, and image resolutions, that are practical to work with. In more simple terms, you need to determine your printer's optimum resolution for printing. Test your printer by outputting a variety of pictures with image

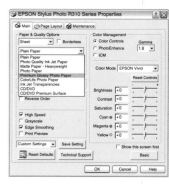

resolutions ranging from 100dpi through to 800dpi. Make sure that all photos were made with the machine set on its best quality setting (5760dpi). The results will show that major changes in print quality are noticeable to the naked eye with resolutions up to about 300dpi. Settings higher than this result in very little change in perceivable print quality. Armed with this information, getting the best from your printer is just a matter of setting its resolution to the finest possible and then adjusting your images to the optimal image resolution, which is generally between 200 and 300 pixels per inches (ppi).

498 Print controls versus software controls

To help resolve the confusion that often surrounds making adjustments to your printed output, it is useful to separate the controls into two sections: those adjusted by the software program such as Photoshop, and those that control the hardware or printer itself. Each section plays an important role. The editing program controls remain the same irrespective of the printer you are outputting to, whereas the hardware dialogs change according to the printer you are using.

499 Printer properties using automatic settings

The printer properties dialog box contains an array of settings and controls that act as the last fine-tuning step in outputting your digital image. Most new users follow the "automatic everything" approach to help limit the chances of things going wrong. For most scenarios, this type of approach produces good-quality results, but if you want a little more control you will have to abandon the "auto" route.

500 Manual printer control

When working manually, there are several adjustments that can be made via the printer control dialog:
• the paper size, orientation, and surface type
• the dots per inch that the printer will place onto the page (printer resolution), and
• color and tone control.

Although using automatic settings provides a less confusing approach to printing, making manual adjustments to the printer setup provides you with more creative possibilities.

Technical terms
The technical terms, abbreviations, and digital jargon of digital photography are summarized below for your further reference and information.

AE
Automatic exposure.

AF
Autofocus or automatic focus.

ALE
Aspherical lens element.

Aperture-priority function
Automatic exposure mode, where the user sets the aperture and the camera automatically sets the appropriate shutter speed for correct exposure.

Artifacts
In digital photography, an (image) artifact is any visible defect or mark that results from an applied process. Usually these are pixels of an incorrect value. Most minor, unwanted artifacts can be easily removed, but a more widespread breakdown of image quality suggests the information in the image is becoming corrupted—because of excessive application of a filter or effect, for example. (Also see Pixel).

AWB
Automatic White Balance. (See White Balance).

Bit
A bit is the smallest piece of computer data, namely one binary digit ("bit" is short for "binary digit"). Binary code deals with calculations in long streams of invisible 1s and 0s, which is all a computer's onboard microchip is processing. More information can be stored in longer strings, so 24-bit systems or files contain more detailed information than 16-bit, for example.

Blurring
This is frequently caused by unsteady hands moving the camera slightly while the shutter is open on longer exposures (camera shake), or by the subject moving. The problem is more noticeable when using long telephoto lenses. Unless you want a blurred subject (to capture the feel of movement in sports, for example) always use at least 1/250-second or 1/125-second exposures with long telephoto lenses.

BSS
Best Shot Selector, a Nikon-patented technology whereby the camera takes a range of shots and retains the one that has the best overall sharpness.

Burning
A digital version of the darkroom technique known as "burning in" specific details at the printing stage. In Photoshop the Burn tool lightens areas of the image.

Burst rate
The number of images that can be recorded in succession by a digital camera.

Calibration
The process of matching the behavior or characteristics of a device to a standard. Computer monitors should be calibrated to ensure they are displaying color accurately.

Card reader
Portable device for transferring digital files from camera to computer monitor screen.

CCD
Charge-coupled device—a type of photosensor.

CC filter
Color correction filter—these can be used to change the color tone, to make it either "warmer" or more blue.

CF card
Compact flask memory card.

Channels
The method that Photoshop and other image-editing software use to manage color, by separating them into separate editable channels. (Also see CMYK, LAB, and RGB).

CMOS
Complementary metal oxide semiconductor—this is an alternative type of photosensor (see CCD).

CMYK
Cyan, Magenta, Yellow, and blacK. The color management system used in commercial printing, whereby colors are formed using combinations of these four inks. In Photoshop, you can choose to edit images for print in CMYK mode, which Photoshop uses to separate an image into four editable color channels. (Also see Channels, LAB, and RGB).

Color cast
A wash of color that can appear on digital images, especially on areas that should be white, and usually when the image has been shot under artificial light. The problem can be overcome using White Balance controls. (See White Balance).

Coma
An optical defect that degenerates the image forming ability of a lens at the edge of the image space.

Compression
The act of reducing the size of a digital file by losing some detail, while attempting to retain as much of the original detail and quality as possible. Compression methods can be "lossless" (little visible detail is lost) or "lossy" (there is a noticeable degrading of image quality). (Also see Resolution, for related issues).

Continuous shooting (mode)
Camera mode that allows you to shoot a series of images in quick succession. The speed of the mode depends on the quality at which you are shooting as higher-resolution images require much more processing time.

CRT (screen)
Cathode ray tube (as in the standard type of computer monitor).

CSR
Continuous Shooting Rate. The number of images that can be taken before the shutter delay locks to enable processing to take place.

Density
The measure of darkness, blackening, or "strength" of an image in terms of its ability to stop light (this is also referred to as its opacity).

Depth of field
The zone of sharpness set between the nearest and farthest points of a scene, depending on your position relative to the subject, and the aperture value (f-number) of your lens.

Digital
Computers and computerized devices, such as digital cameras, manage and store information as strings of binary digits, or "bits." A digital system is any one that processes data in this way, and then turns it back into information that you can understand via an interface, such as a computer monitor.

Dodging
A digital version of the darkroom technique, also known as "holding back," which limits exposure at the printing stage. In image-editing software, the Dodge tool darkens specific areas of the image.

DPS
Digital photosensor. The device that collects light and turns it into digital data.

DSLR
Digital single-lens reflex camera. (See SLR).

Electronic noise
See Noise.

Exposure
The act of opening the shutter to allow light to fall onto the sensor via the lens to record a scene. A fast or slow exposure describes the length of time the shutter remains open and the sensor is exposed to the light. (Also see overexposure and underexposure).

Fill flash
A flash mode whereby the flash is used to supplement another light source, such as daylight, to ensure an even spread of light, or to pick out details.

Flash
An onboard or external light source for photography, which produces a short burst, rather than a continuous source, of light that is calibrated to be of a consistent and neutral color.

Firewire
A high speed type of computer connection that is standard on many digital still and video cameras for transferring image data to your computer at high speed.

Flatten
In Photoshop and other layer-based image-editing programs, the process of compiling all of an image's separate layers into a single layer containing all of the image information. Once flattened, edits can no longer be made in isolation to information that previously resided on a separate layer.

F-number
Aperture numbers are described in terms of their f-numbers, such as f/2.8 and f/1.6. Smaller f-numbers let more light into the camera, and bigger f-numbers, less light.

FPS
Frames per second–the number of images that can be recorded by a digital camera within a one-second period.

Gigabyte (GB)
A unit expressing digital file size or memory capacity. One Gigabyte equals one thousand megabytes.

GN
Guide Number. The measure of a flash unit's power.

Grain
The gritty texture characteristic of fast films, which can be imitated digitally in Photoshop and other image-editing programs to create a variety of effects. Fast films have a larger amount of light-sensitive silver halide crystals, which are often visible as texture in the final image.

Graphics tablet
A digital input device that works like a pen on a pad, used by some professionals as their primary interface for image-editing work alongside a QWERTY keyboard.

HD
The hard disk drive on a computer that serves as a computer's "filing cabinet" for storing data, such as your photography.

Histogram
A graphic representation of tonal range in an image.

Hyperfocal distance
A focus setting used to give maximum depth-of-field.

IF lens
Internal Focusing lens. Lenses with IF do not extend outward when focusing.

ImageReady
An Adobe software partner to some versions of Photoshop, designed to prepare images for specific purposes, such as for interactive uses on Web sites.

Interface
(vb) The way in which a peripheral (such as a scanner) links to the computer; or (n) a device or system via which you (or another device) can communicate with a computer, or see the results of your work.

Interpolate
The way in which the digital camera calculates a color value for each pixel.

IS lens
Image stabilization lens.

ISO (E)
International Standards Organization–an industry standard measurement for film and (equivalent) DPS speed.

JPEG
Joint Photographic Experts Group. A file format, established as an industry standard, for saving images to memory, which reduces file size. Successive saving in JPEG format applies the same compression ratio each time. JPEGs can be of any quality from fine through to low resolution, for use on the Web.

LAB
An image-editing color channel mode used by many professional photographers, consisting of Lightness (or Luminance) plus A and B channels.

Layer
In Photoshop and some other programs, each new element of, or amendment to, an image is (or can be) made on a separate, individually editable layer, as though it were on an invisible overlay. In this way all editing is non-destructive of the original image, giving you an extremely high level of control over each element.

LCD panel
Liquid Crystal Display panel. The viewing panel on a digital camera.

LCD screen
Liquid Crystal Display screen. The superslim type of computer monitor screen, which saves space and offers fair clarity.

Macro
A term used to describe close-up photography. The lens itself determines how close you can focus, and the best results are gained from specially designed macro lenses.

Media player
Any portable digital device, such as an iPod, which may be used for storing and retrieving, or playing, a variety of different digital media types, such as photos, music, or videoclips.

Megabyte (MB)
A unit of digital file size or storage capacity. One megabyte equals one thousand kilobytes (kb).

Memory card
An electronic card that can be inserted into a digital camera to store images in the form of a digital file of binary numbers.

Memory stick
A form of permanent recording device on which to store digital images, developed by Sony.

Microdrive card
A type of memory card for digital cameras.

Mode
A particular arrangement or set of operating conditions. Most digital cameras have several modes, offering a range of preset or manually addressable functions for certain shooting conditions.

Multimedia card
A type of memory card for digital cameras.

NGD filter
Neutral density graduated filter, a filter that darkens across its surface.

Noise
Electronic disturbances that affect the quality of the photographic image, also known as digital grain.

Noise filter
Photoshop filter that can be used to simulate film grain and other image artifacts.

NR
Noise reduction. In photography, a method of removing unwanted image artifacts. (See Artifacts; Noise).

Overexposure
The act of allowing light to fall on the sensor (or film, in film photography) for too long, resulting in images that are pale and washed out (overexposed).

Oversampling
A scanning technique that helps to remove noise in the image.

Panorama
A single image stitched together from several separate images shot from a tripod that is gradually rotated through 360°.

PD
Photodiode. One of millions of light-sensitive cells in an electronic digital photosensor (DPS).

Peripheral
An add-on to a computer, such as a scanner, printer, etc.

Photoshop
The industry-standard desktop image-editing and creating software, produced by Adobe. Photoshop Elements is a less expensive version with fewer features, while "CS" versions stand for Creative Suite, and interface more easily with other Adobe products.

Photomerge
Application for stitching together images to form a single panoramic shot.

Pixels
Short for "picture elements," the individual points of light that make up a digital image. Broadly speaking, the higher the number of pixels, the more detailed the image (and the higher its "image resolution").

Prism finder
A viewfinder that projects an image, using a system of mirrors.

RAM
Random access memory—a computer's built-in memory.

RAW
A type of picture file that takes data directly off the digital sensor for storing on the memory device.

Red eye
A familiar image anomaly that occurs when direct on-camera flash is used when photographing someone at close range, caused by the flash bouncing off the retina and being recorded as a disk of red. Most cameras have a red-eye reduction mode, which works by firing a swift succession of strobe-like flashes that close down the subject's iris before the shutter fires.

Resolution
An often confusing concept. Very broadly speaking, a high-resolution image is one that contains the highest number of pixels (picture elements), or dots of light, resulting in a more finely detailed recording of a scene. Of printing and computer monitor displays, resolution refers to the number of elements (dots of ink, or dots of light) needed to reproduce an image accurately. Computer monitors have a much lower resolution (72 dots per inch) than printed matter (300 or more dots per inch). Therefore, an image saved down to Web resolution can appear sharp and detailed onscreen, but seem very poor quality when printed. (In this way, file sizes can be kept as small as possible for posting images online for quick download).

SBR
Subject Brightness Range. The brightness of a subject, compared to the brightness range of the entire scene.

SD card
Secure Digital card. A type of memory card for digital cameras.

Sharpen
In Photoshop and other image-editing software, you can use one or more of the various Sharpen tools to increase the contrast between pixels on the edges of objects within an image, creating the impression of a sharper, more detailed shot. Sharpening will not compensate for an out-of-focus image, however. All digital images require slight sharpening, which can be done in-camera.

Shutter-priority function
Automatic exposure mode, where the user sets the shutter speed and the camera automatically sets the appropriate aperture for correct exposure—also known as shutter priority auto exposure.

SLR
Single Lens Reflex camera. A type of camera that allows you to see through the camera's lens as you look through the viewfinder.

SM card
Smart Media card. A type of memory card for digital cameras.

Soft box
A large cloth attachment that turns a point light source into an omnidirectional light source, and which therefore softens and diffuses the light, spreading it around the subject. These are usually used on large, external flash units by professional photographers.

Sponging
A digital technique in which colors in the image are deepened, or lightened, for artistic effect.

Stitching
The process of using image-editing software to join together a series of separate images into a single image, usually to create a panorama. Images are shot with a slight overlap so that the stitching software can find the correct join.

Teleconverter
An alternative to a telephoto lens, used to increase the effective focal length of the camera's lens.

Telephoto
A lens with a long or very long focal length, which lets in the least amount of a subject (the opposite of a wideangle lens), and is useful for focusing on distant objects and keeping vertical lines perpendicular.

Texturizer
A Photoshop filter that can apply different types of texture, such as canvas or stone, to digital images, sometimes used subtly in conjunction with toning to create "aged" effects on images.

TIFF
Tagged Image File Format. A standard file format that offers high image quality, and is often used for images that are destined for print. Some cameras offer it onboard, but it can eat up space. Resaving a TIFF does not compress the file. (Also See JPEG).

TTL metering
Through the lens metering–a system of light metering that measures the amount of light reflected through the lens.

Underexposure
The act of allowing light to fall on the sensor for too short a time, resulting in images that are muddy, dark and poorly detailed (underexposed).

USB connection
Universal Series Bus. A type of computer/peripheral link that remains standard on many computers and devices, but which is generally superceded by the much faster FireWire for high volumes of data that need to be transferred quickly, such as digital image files and videoclips.

UV filter
Ultraviolet filter, which filters out ultraviolet light.

VR head
Virtual Reality head–a slight misnomer. VR heads are attached to tripods for the specific task of shooting the individual images needed to create panoramic shots. VR heads rotate through set increments, so the degree of rotation is constant in each image, making it easier to align them and stitch them together later into a single editable image.

VR photography
The shooting of a series of panoramic images with the intention of displaying them in the form of animated rotations or interactive movie clips.

VR lens
Vibration reduction lens.

White Balance
White Balance (WB) is a camera setting, or range of settings, which overcomes color casts that appear in digital images because of the different color temperatures of light sources, such as florescent tubes or incandescent household bulbs. The camera refers to a stored reference white and adjusts itself to ensure that white objects appear white in the final image. In film photography, the problem was overcome using filters on the lens.
(Also see Color cast).

Zoom (lens)
A lens, sometimes motorized, that has a variable focal length, from wideangle all the way through to telephoto. Many cameras come with a zoom lens as standard, giving you the broadest possible range of shooting options, although often lacking the greatest wideangle and telephoto benefits of a specialist lens at either extreme.

Index

Acknowledgments

Always for Kassy-Lee, but with special thanks to Adrian and Ellena for putting up with an author for a father for the last few months. Yes it is over–until next time at least! And thanks to the hardware and software manufacturers whose help is an essential part of writing any book of this nature. In particular I wish to thank technical and marketing staff at Adobe, Microsoft, Canon, Nikon, and Epson. And finally my thanks to all the readers who continue to inspire and encourage me with their generous praise and great images.

Picture and other credits
With thanks to the guys at www.istockphoto.com and www.ablestock.com for their generous support in supplying the tutorial images for this text. Copyright © 2005 Hamera and iStockPhoto and its licensors. All rights reserved. Select other images (Introduction) courtesy of Digital Vision. Additional photography courtesy of Tony Seddon and Jane Waterhouse (Introduction; Galleries 1 and 2), © 2005; and Chris Middleton (Tip 64 portrait), © 2005. All other images and illustrations by Karen and Philip Andrews © 2005. All rights reserved. Introduction and additional text Chris Middleton and courtesy of Chris Weston.

Philip Andrews, 2006